IMAGES
of America

AMITYVILLE

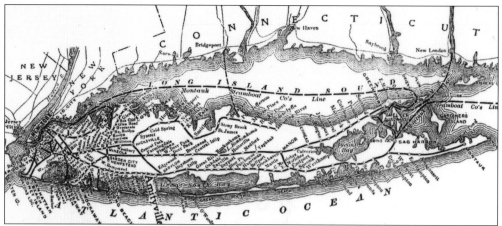

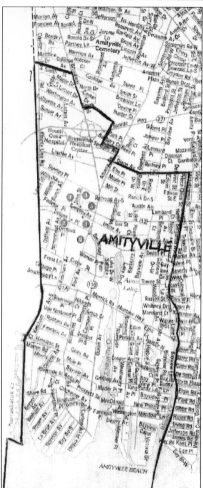

Amityville is on Long Island's Great South Bay. The village is part of the town of Babylon and is located about 35 miles east of New York City.

On the cover: Please see page 21. (Amityville Historical Society.)

IMAGES
of America

AMITYVILLE

Amityville Historical Society

ARCADIA
PUBLISHING

Published by Arcadia Publishing
Charleston SC, Chicago IL, Portsmouth NH, San Francisco CA

Printed in the United States of America

Library of Congress Catalog Card Number: 2006924320

For all general information contact Arcadia Publishing at:
Telephone 843-853-2070
Fax 843-853-0044
E-mail sales@arcadiapublishing.com
For customer service and orders:
Toll-Free 1-888-313-2665

Visit us on the Internet at www.arcadiapublishing.com

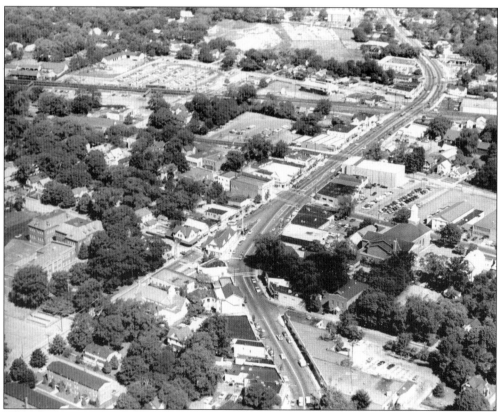

This aerial view shows the heart of Amityville. The Triangle Building is near the left center.

CONTENTS

ACKNOWLEDGMENTS

Amityville was compiled by Seth Purdy, curator of the Amityville Historical Society, and Jeanette Henderson. It was written in collaboration with Virginia Breen, Richard Handler, Kenneth Lang, William T. Lauder (village historian), William Lozowski, Cathy Lozowski, Jennifer McCarthy, Andrew Purdy, and Vincent Ricciuti Jr.

The Amityville Historical Society was formed in 1969 by some 30 residents who saw the need for an organization that would be responsible for recording the history of the area. At that time changes were rapidly occurring, and the knowledge of the community's heritage was disappearing. The new society gained many enthusiastic members during its first year. In 1971, the society received a gift of a former bank building from the Franklin National Bank. That building became a museum for the display, recording, and promotion of the knowledge of Amityville's history. Today the Lauder Museum is a major source of historical information.

INTRODUCTION

This is indeed a delightful collection of selected nostalgic scenes of Amityville over the last two centuries. Amityville's recorded history, however, started in the 1650s. It was then that the folks in Huntington Town, on the north shore of Long Island, traveled south to avail themselves of the salt hay on the meadows and islands in the Great South Bay. They soon realized the full virtues of the area, and, in 1658, they purchased the bay front parcels known as West Neck South and Josiah's Neck from the local American Indians.

In 1664, King Charles II gave the area to his brother, the duke of York. Not long afterward, Thomas Carman established a mill on the west boundary and Eliphalet Oakley built his mill just east of the settlement. Later Oakley gave the mill to his son-in-law, Thomas Ireland. The mills, together with the neighboring woodlands thick with game, good soil, and the salt hay, waterfowl, fish, and shellfish in the bay, attracted farmers and bay men to the settlement.

By 1774, the Methodists, then the majority, established regular worship. Thus, in that ordered and sylvan paradise, the community flourished and prospered.

Through the Revolutionary War, the farms were busy supplying the needs of the city to the west and fending off occasional foraging parties of British. After the war, in 1790, Pres. George Washington, on a tour of Long Island, paid a visit and stopped for lunch at Zebulon Ketcham's Inn. Washington must have enjoyed it because he gave the innkeeper's young daughter a "half joey," or 2¢ coin.

Travel was by horse, wagon, or stagecoach on unpaved roads. Montauk Highway, or Merrick Road (formerly King's Highway, South Country Road, or Main Street), was a toll road maintained by the abutting landowners. There were two tollgates: one at Carman's Road and the other at County Line Road.

In 1840, after a raucous meeting, the community changed its name to Amityville, meaning "friendly village"—although Contrary Ville had been suggested. The importance of the village by the 1850s was reflected in the fact that Col. Richard J. Cornelius, one of only two New York State assemblymen from Suffolk County, resided in Amityville. By 1858, the village had a post office, church, school, general store, blacksmith shop, livery stable, and resident doctor, as well as two mills, two tollgates, two stage stops, and several taverns.

During the Civil War, the community was well represented in the Army of the Republic. Twelve local soldiers made the supreme sacrifice.

In 1867, the steam railroad arrived and connected the community to the city on the west, an hour's trip. This new connection created an air of independence from the northern portion of the island. Amityville became a prime summer vacation spot on the south shore,

with a dozen fine hotels and rooming houses. Summer ferry service was available to the ocean barrier beaches.

Simpson Methodist Church opened in 1869 on North Broadway. In 1872, the southern half of the town of Huntington seceded and became the town of Babylon.

In the 1880s, some of the largest hospitals on Long Island were created to cater to rich and wellborn "nervous invalids." The Long Island Home, Louden-Knickerbocker Hall, and the Brunswick Home were among them. St. Mary's Episcopal Church was established in 1886, and the Jewish community started in 1889. Also in that decade, two local newspapers, the *Dispatch* and the *Chronicle*, were established.

During the 1890s, large three-and-a-half-story hotels were constructed on the waterfront, which also supported a lively boatbuilding trade. A special stable was maintained on Main Street (Merrick Road) for William K. Vanderbilt. The community's continuing growth led to the establishment of the Bank of Amityville, the first bank in the town of Babylon.

Located along the Merrick Road were an ocean beach ferry terminal, a local men's club, and the mills. The downtown business district, on "the road to Huntington," contained the imposing Triangle Building, which housed the bank, post office, courtroom, and lawyer offices.

In 1894, the village elders sought closer control over local matters. Thus the hamlet became the incorporated village of Amityville. In the same year, the old wooden schoolhouse was replaced with a classic brick building, complete with bell tower. The new building accommodated both the grammar school and the high school.

Near the conclusion of the decade, St. Martin of Tours Roman Catholic Church was founded in 1897, and the Amityville Club was established in 1898.

As the 20th century approached, the Unqua-Corinthian Yacht Club was founded in 1900. Charles F. Delano purchased the *Dispatch* and renamed it the *Amityville Record*. Mary P. Myton formed a literary society in 1904, and that society helped organize the Amityville Free Library in 1907. In that same year, a second bank, the First National Bank and Trust Company, was established. Paul Bailey, renowned historian and writer and publisher, initiated a second local newspaper called the *Amityville Sun*. Later the newspaper's name became the *Long Island Sun*. In 1916, Lawrence Sperry launched the first guided missile from a site in Amityville. During Prohibition, Alphonse Capone took up summer residence for about three years. Continued community growth necessitated the construction of a new high school in 1924. The railroad was electrified in 1925, providing convenient and direct service to New York City.

During the following decade, St. Paul's Lutheran Church opened in 1930, and a new junior high became part of the school system. The Sunrise Highway was extended through the northern section of the village in 1932.

In 1940, a public beach was established on land along the bay that the village had purchased from the estate of Alfred G. Vanderbilt.

Still, with all the many changes, the village retains its rural charm and flavor, upholding its reputation as "the friendly village."

William T. Lauder
Village of Amityville Historian

One

THE VILLAGE LANDMARK AND LOCAL TRANSPORTATION

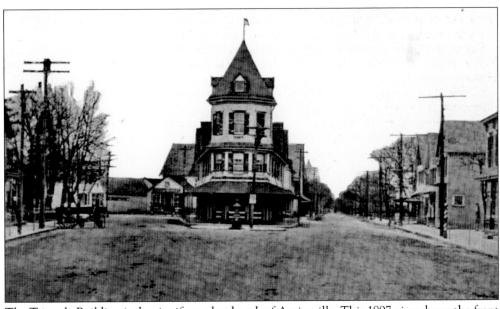

The Triangle Building is the significant landmark of Amityville. This 1897 view shows the front of the building, located at Broadway and Park Avenue. Notice that the roads are unpaved.

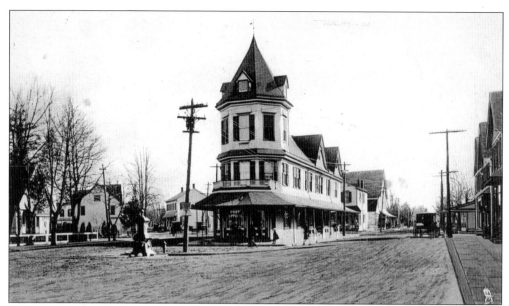

Constructed in 1892, the Triangle Building stands in the center of the village on land that was previously a picnic grove. Its triangular shape was designed to fit into the land plots. This 1908 photograph was taken looking southeast. An early automobile is on the Park Avenue side (right), and more than one horse and wagon can be seen on the Broadway side (left) in the distance.

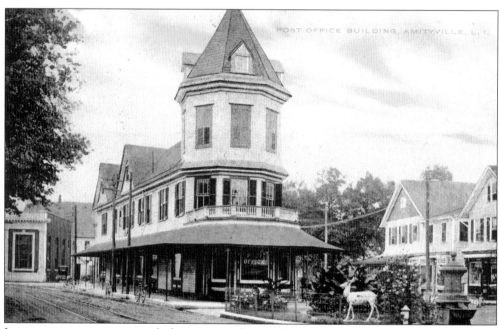

Its appearance suggests a stately dowager presiding with dignity over the village. This 1912 scene shows the early landscaping that included an on-site water trough for animals. The trolley track for the Huntington-Amityville trolley is visible in the road.

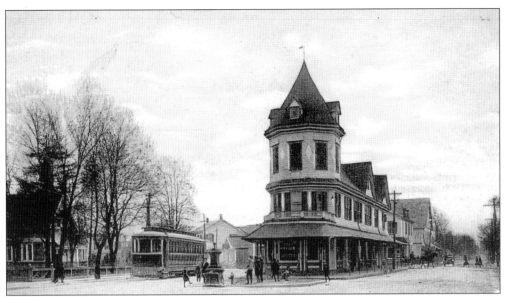

The Triangle Building has served as the village court, village hall, and village post office. It was also the community gathering place, as residents had to pick up their mail there. In this 1915 view, the trolley is heading south and the roads are still unpaved.

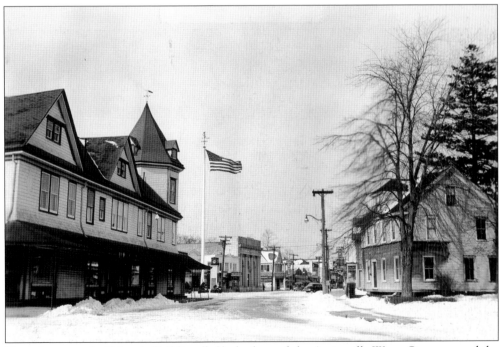

Over the years, the Triangle Building (left) also housed the Amityville Water Company and the Electric Power and Light Company offices. The Terry-Burr house (right) is ready to move to a new location. The photograph was taken from the southeast side of Broadway.

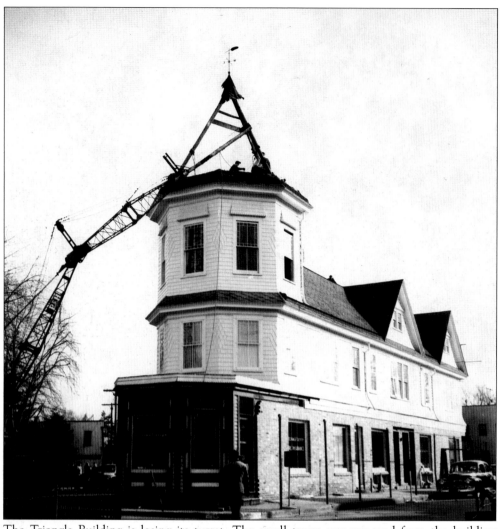

The Triangle Building is losing its turret. The small tower was removed from the building because the owner at the time felt that it was in need of extensive repair.

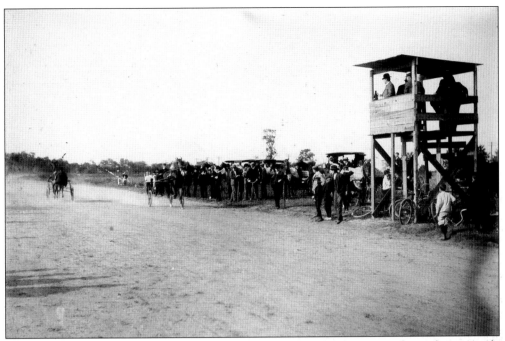

The Amityville Trotting Association Racetrack was a harness-racing track on the west side of North Broadway beyond Marilyn Avenue. The track was financed in 1895 by a number of prominent village residents.

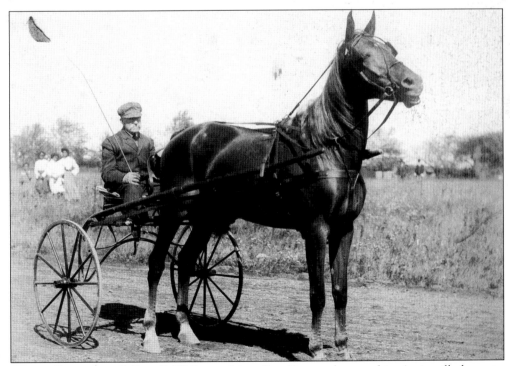

Amityville resident Gilbert P. Williams drives Best Tracy, who raced in Amityville between 1895 and 1900.

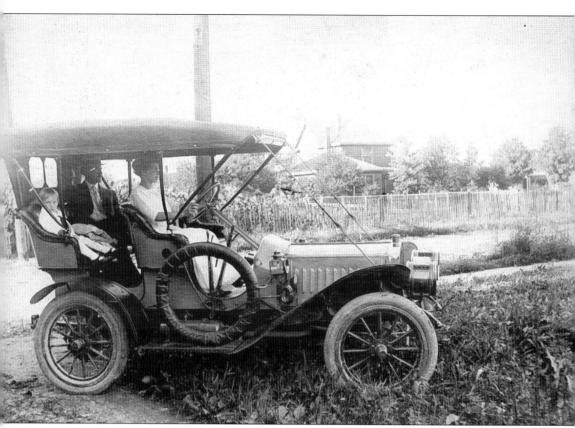

Members of the Case family sit in their car in front of their home, at 82 Park Avenue, in 1920. From left to right are Norton, Herbert, and Bertha Case.

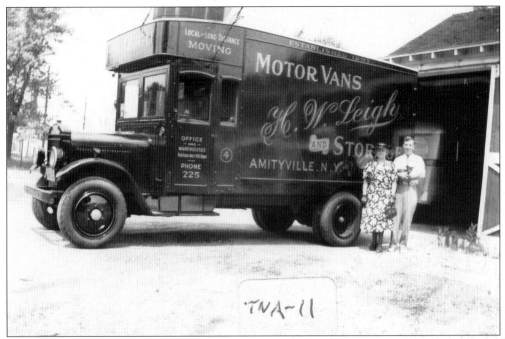

TNA-11

Established in 1897, H. W. Leigh operated motor vans, a storage facility, and a taxi service. This picture of van No. 4 was taken in 1920. The company offered local and long-distance moving. The telephone number at the time was 225.

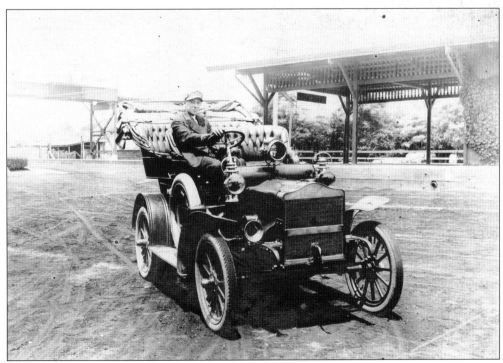

Louis Schafer was a driver for Leigh's Taxi Service. He is pictured in a right-hand drive automobile at Amityville Railroad Station.

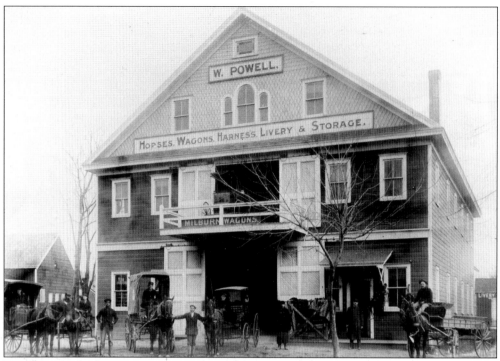

Nine men display horses, carriages, and wagons at W. Powell's livery stable around 1890. Powell's offered horses, wagons, harnesses, livery, storage, and stage service.

W. POWELL'S STAGE SERVICE
TRAIN CHECK
WEST BOUND TRAINS

Trains	Pas'ng'rs	New P'nt	Other
4.58a m			
5.46			
6.32			
7.05			
7.26			
7.42			
8.03			
8.53			
10.10			
10.37			
12.07 am			
2.38			
3.54			
5.17			
6.12			
8.12			
8.58			
10.31			
12.10			
Totals			

This is a check sheet for W. Powell's stage service. It includes times for westbound trains, a column for passengers, a column for Hotel New Point, and a column for "other."

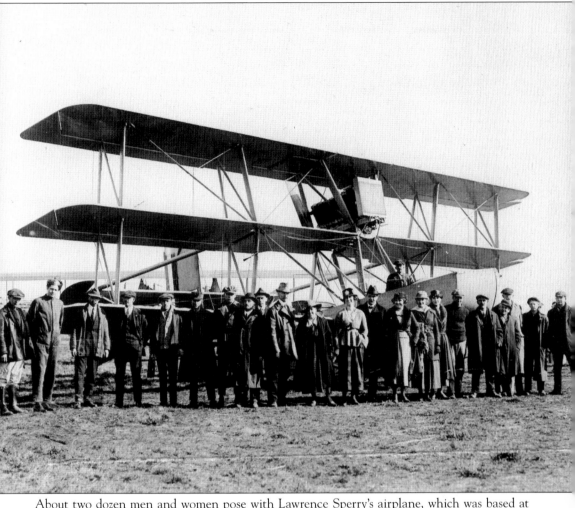

About two dozen men and women pose with Lawrence Sperry's airplane, which was based at Unqua Place in Amityville in the 1920s.

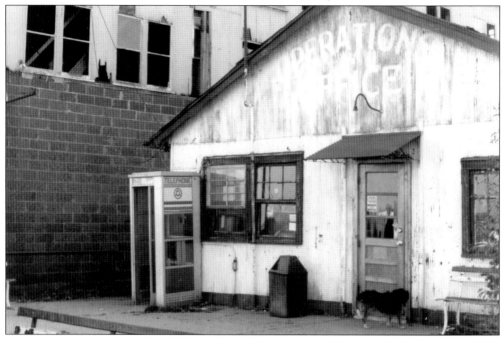

Zahn's Airport was originally an orchard. The landing strip was cut straight through the rows of trees. In time, Zahn's became one of the largest general airports in New York State. Around 1935, this building served as the operations office at Zahn's Airport. Notice the dog waiting outside the door.

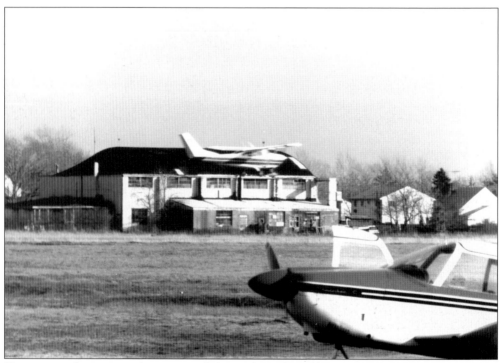

Here one airplane sits on the runway while another takes off.

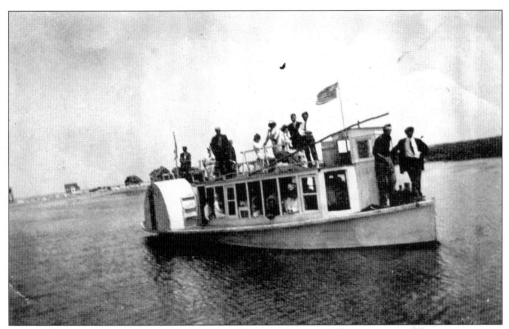

The *Adele* was one of three ferries that ran to Hemlock Beach. This photograph dates from 1922.

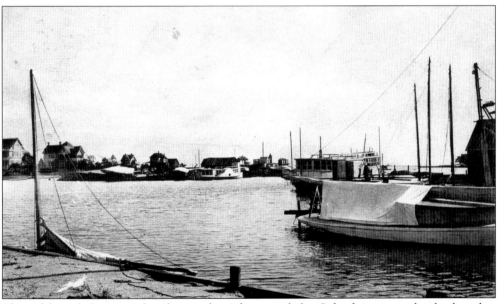

The *Adele* and the two other ferries, the *Atlantic* and the *Columbia*, were side-wheelers that sailed from the Amityville Creek. Passengers bound for Hemlock Beach boarded them at the Ocean Avenue dock. This view of the creek was taken looking southward.

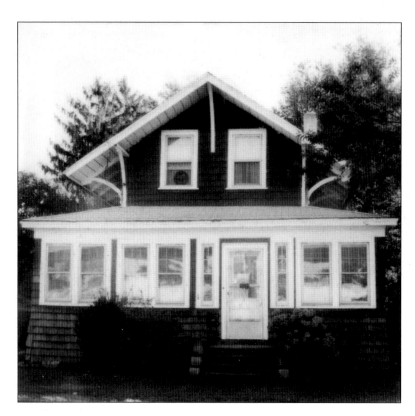

Amityville's first depot was for the Southside Railroad. The building was later renovated for use as a private home.

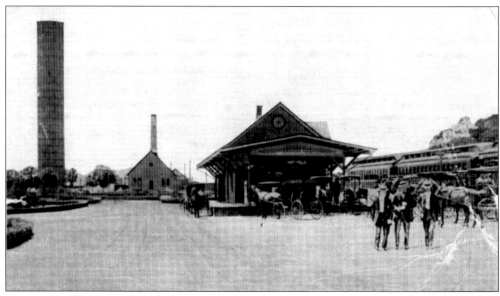

The Amityville Railroad Station was built in 1867 to replace the depot built for the Southside Railroad. Pictured around 1898, it is a busy place, with wagons and coaches waiting to pick up passengers from the incoming train. In the background are the electric and water company buildings (left).

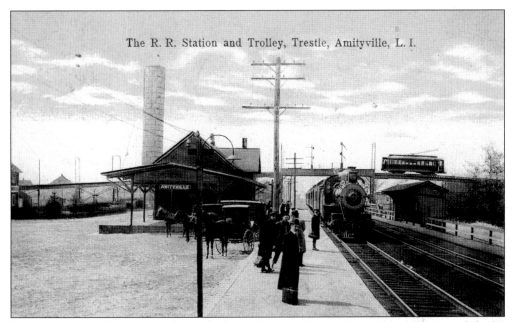

The R. R. Station and Trolley, Trestle, Amityville, L. I.

Men—all wearing hats—wait alongside the track at the Amityville Railroad Station, while the Huntington-Amityville Trolley crosses the viaduct in the distance.

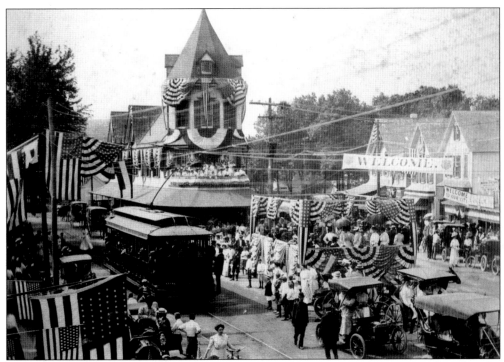

August 25, 1909, was celebrated in downtown Amityville as opening day for the Huntington-Amityville trolley. "Welcome to our city," the signs say.

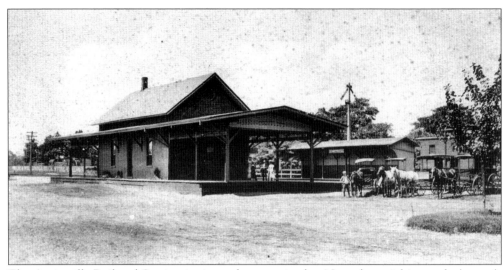

The Amityville Railroad Station is pictured on a quiet day. Note the weighing scale (center), a service for waiting passengers. Along the track, an advertising sign painted on the wall (left) reads in part "lumber, brick, stone, coal."

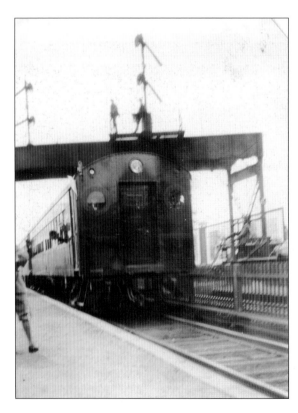

The first electric train arrives in Amityville on May 21, 1925.

Two

THE DOWNTOWN DISTRICT AND HOTELS

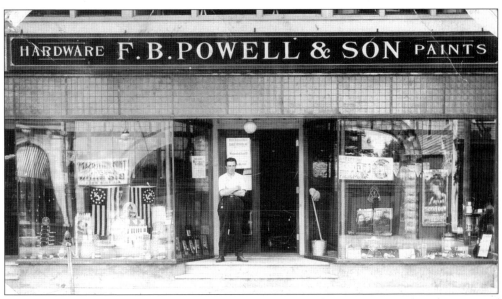

F. B. Powell and Son sold hardware and paint. The hardware store was located in the center of downtown. The building was originally used as the town hall for the town of Babylon, which was formed in 1872. Note that near the door are a mop and bucket (right) and two signs announcing local dances (left): the "First Annual Ball, Eagle Council 45, Wednesday, June 23" and a "Grand Shirtwaist Dance."

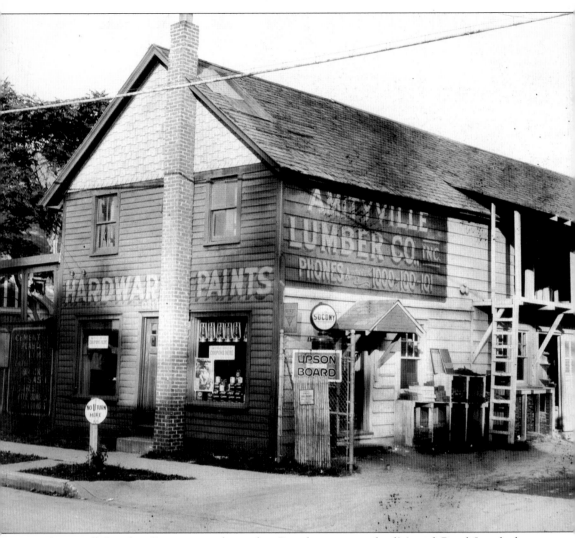

Amityville Lumber Company was located on Broadway just north of Merrick Road. Its telephone numbers were "Amityville 1000-100-101." The store carried "cement, lath, brick, sash, doors, wall boards, mouldings," according to the outside wall (left). Its brands included Bird roofs, Upson processed board, and Socony gasoline (right). Two notices in the windows announce "Amityville Lions Club coupons here." The round sign near the curb says, "No U turn here," with the police department's initials, "P.D.," at the bottom.

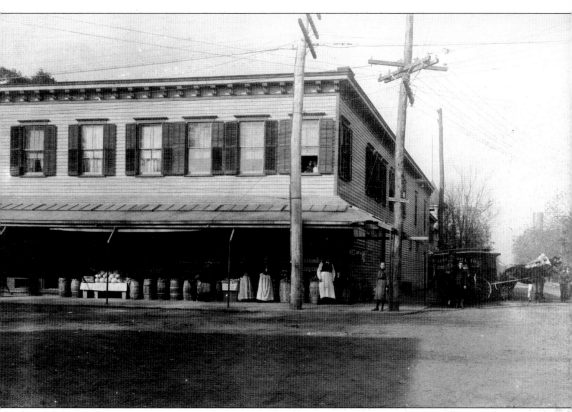

Adolph Maul Groceries stands on the southwest corner of Broadway and Greene Avenue. Nine people pose outside the store for this c. 1906 photograph. Four young men are with the four horses that pull the delivery wagons (right). A cat pauses next to the younger girl (left). Barrels of produce line the sidewalk, and neatly stacked cans show inside the windows. A sign on the Greene Avenue side advertises India relish. Next door to the grocery store is a shoe store (left). The grocery store site later became that of the First National Bank and Trust Company.

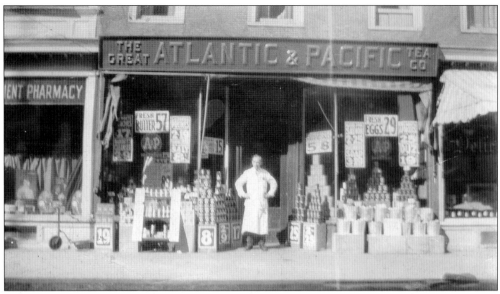

The Great Atlantic and Pacific Tea Company (A&P), on Broadway and Merrick Road, was one of the first stores of a national grocery chain. In front of the store is William Hopkinson, who worked at the A&P in 1924, when this photograph was taken. Next door is the Clement Pharmacy (left).

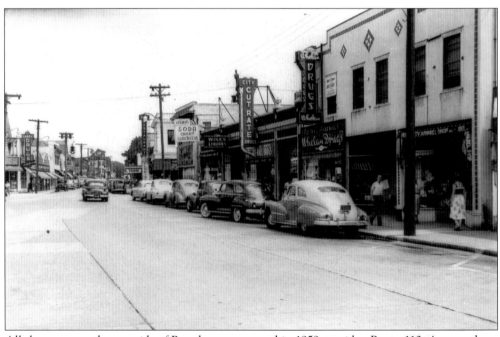

All the stores on the east side of Broadway were razed in 1959 to widen Route 110. Among those pictured are, from left to right, a restaurant, a florist, Fischer's soda shop and luncheonette, a package store, City Cut-Rate Drugs, Polsky's Pharmacy (Whelan's Drugs), and Amity Apparel Shop.

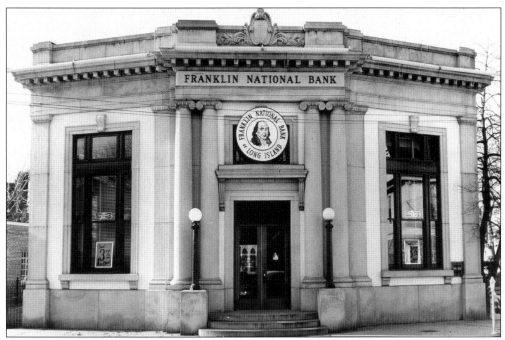

The original building was the Bank of Amityville. Eventually that bank merged with the Franklin National Bank of Long Island. In 1971, the Franklin National gifted the building to the Amityville Historical Society. The historical society is located here today.

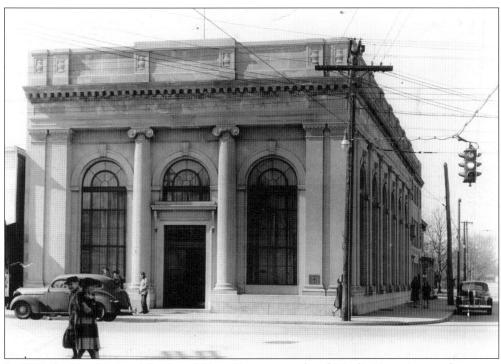

In 1927, the First National Bank and Trust Company replaced Maul's Groceries, on the corner of Broadway and Greene Avenue. This picture was taken around 1940.

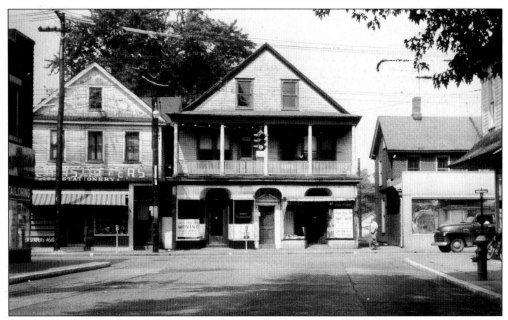

The center of downtown, at Broadway and Oak Street, is pictured just prior to the demolition of these buildings. The buildings were taken down to allow for the westward extension of Oak Street. Among the places shown in this c. 1953 photograph are, from left to right, a tailor shop, Christoffer's Stationery store, and a curtain shop.

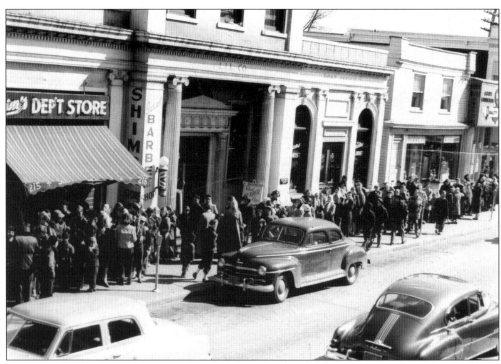

On the east side of Broadway between Oak Street and Union Avenue, people wait patiently in line for admission to the Amityville Theater.

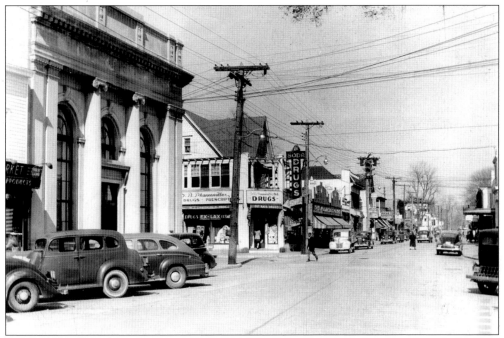

This view of the Broadway business district was taken looking north from the Triangle Building around 1940. From left to right are a meat market, the First National Bank and Trust Company, Phannemiller Drugs, a bar and grill, a department store, a stationery store, and a bakery.

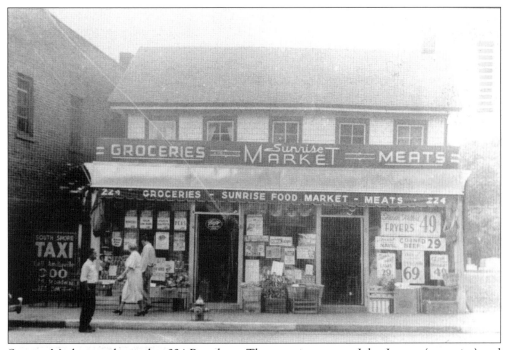

Sunrise Market was located at 224 Broadway. The proprietors were John Lomot (groceries) and Edward and John Johnson (meats). Among the prices being advertised were "fresh killed fryers," 49¢ a pound; corned beef 29¢ a pound; and legs of spring lamb, 69¢ a pound.

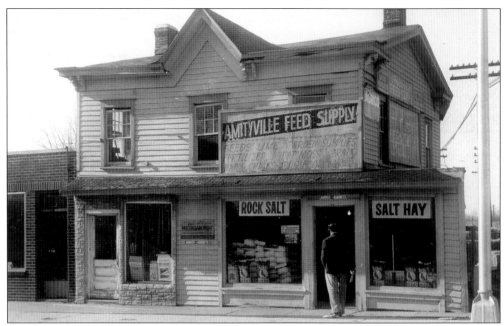

Local farmers shopped at Amityville Feed Supply. The store offered "feeds, lime, garden supplies, fertilizer, peat moss, grain, baby onions, dog food," as well as rock salt and salt hay. It carried Agrico and Agrinite products, Michigan peat, and Red Robin wild bird seed.

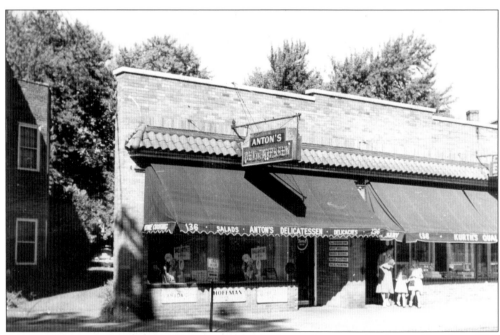

Anton's Delicatessen and Kurth's Bakery were located next door to each other on Broadway. The Bay Village Inn occupied this site later. The delicatessen advertised Canada Dry, Hoffman's, and Bond Bread. The sign by the door lists delicacies such as baked Virginia ham, roast beef, baked beans, baked custard, and rice pudding.

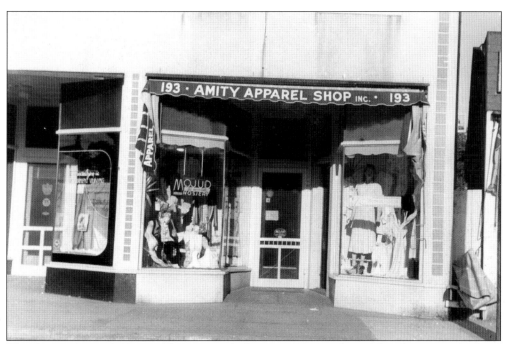

The Amity Apparel Shop sold women's clothing at 193 Broadway. The shop carried Mojud hosiery. This photograph was taken in the 1950s.

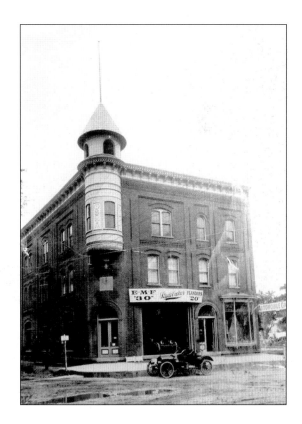

The Homan Van Tassel Department Store was located in this handsome building. Later the space became an automobile showroom. A Studebaker is on display.

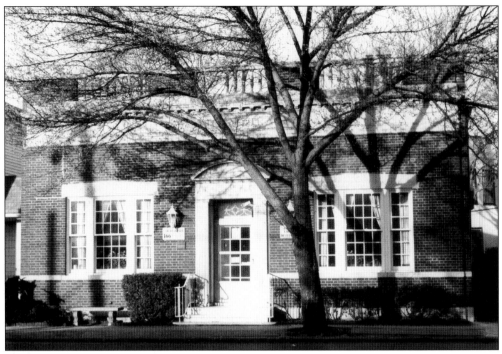

The brick Amityville Free Library replaced a wood frame building.

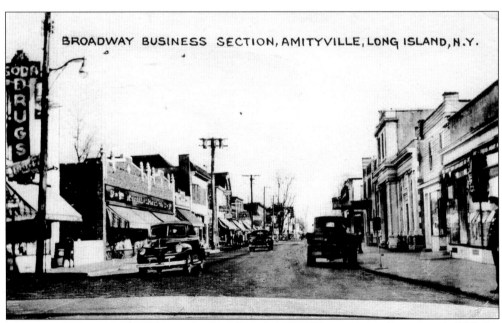

BROADWAY BUSINESS SECTION, AMITYVILLE, LONG ISLAND, N.Y.

This view, looking northward into the Broadway business district, was taken around 1936. On the right side can be seen the Amityville movie theater's marquee.

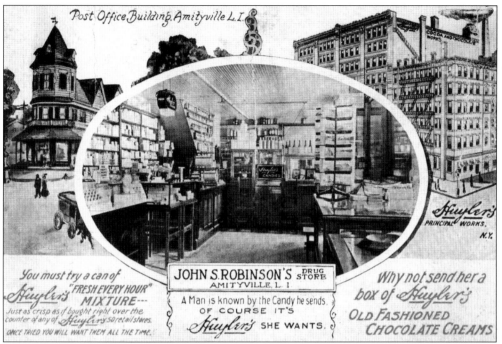

This postcard advertisement for John S. Robinson's Drug Store shows, from left to right, the post office building later known as the Triangle Building, the interior of drugstore, and the plant where Huyler's chocolates were made.

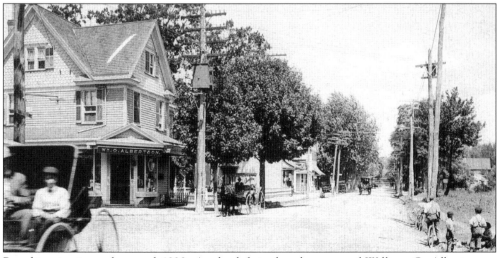

Broadway is pictured around 1898. At the left is the pharmacy of William G. Albertson, a well-known establishment.

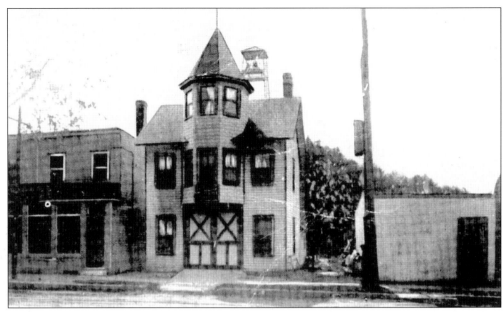

This is the headquarters of Amityville Hook and Ladder Company No. 1 around 1880.

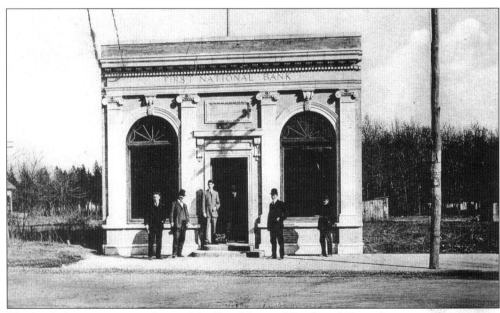

The bank directors pose in front of the First National Bank and Trust Company on Broadway around 1907.

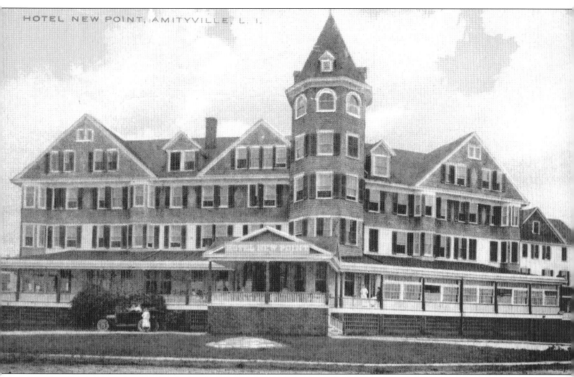

Once a summer resort, Amityville attracted families who wanted to escape the crowds and the heat of the city. Several grand hotels were built along Great South Bay, the most famous of which was Hotel New Point. Local carpenters from the Haff, Ketcham, Purdy, Sprague, Smith, Wanser, Weed, and Wicks families helped build New Point. The hotel was three and a half stories high and had 60 guest rooms, a large veranda, a bathing beach with bathhouses, and a carriage house. It was a scheduled stagecoach stop on the Powell Livery schedule from the Amityville Railroad Station. In 1916, an auction was conducted to sell the contents of the hotel. Afterward the building was used for fund-raisers and as a camp—first the New York Herald Tribune Fresh Air Camp and then, in its last days, the Meroke Day Camp.

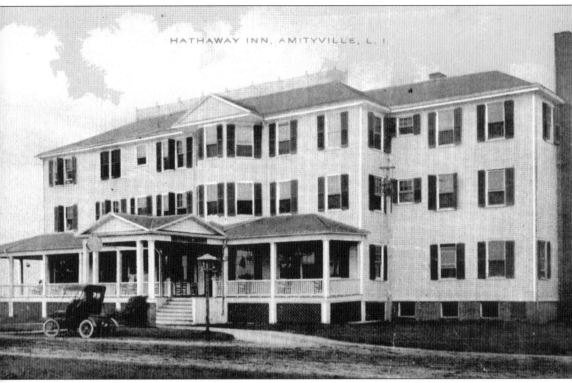

As business flourished, a second hotel called the New Point Inn was built in 1900 on the west side of Grand Central Avenue. In 1906, it became the Hathaway Inn. The Hathaway was destroyed by fire in 1951.

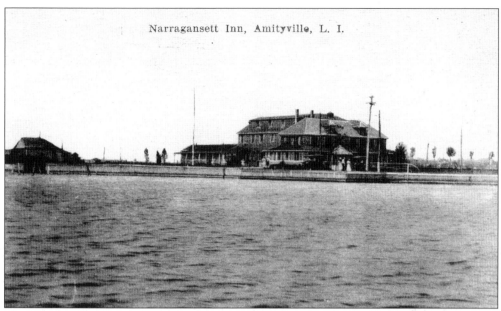

Narragansett Inn, Amityville, L. I.

The Narragansett Inn was originally known as the Conklin House, and Bernard Conklin was the first proprietor. Carl L. Fuchs was a later proprietor. Like the New Point, the Narragansett fronted Great South Bay, and it arranged boating excursions for its guests. The hotel was located at the foot of Ocean Avenue at the south terminal of the Amityville-Huntington Trolley Line, and its bandstand was frequently used as a shelter by guests awaiting the trolley. Renamed Shanahan's, the hotel operated year-round during the Great Depression. Renamed Shangri-La, it opened only in the summer and then changed back to year-round. Toward the end, it became primarily a restaurant, and then in 1996, it was destroyed by fire.

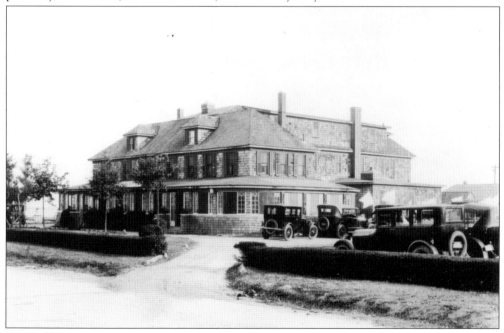

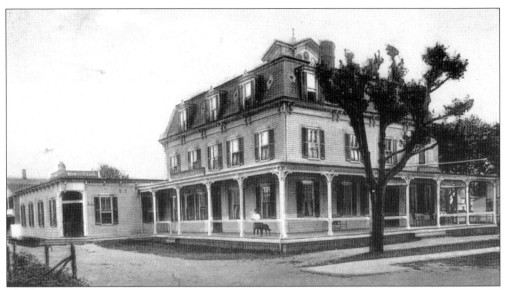

In 1870, the Wardles Hotel stood on Broadway near the railroad station. It was in a convenient location for businessmen who traveled to Amityville. Later the hotel became known as Kiernan's, the veranda was enclosed, and vintage automobiles parked along the road.

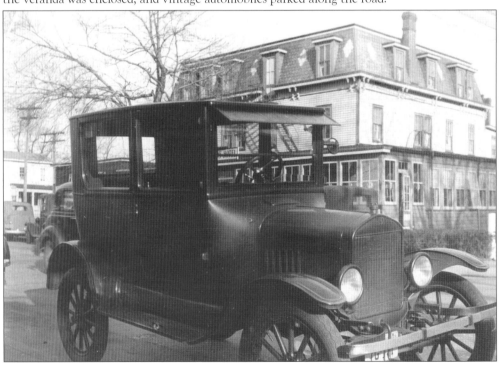

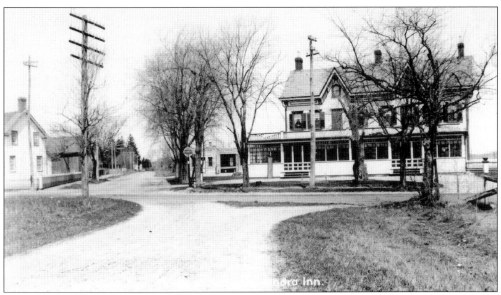

The Alexandra Inn, or Alexandra Hotel, was located on Merrick Road at Bayview Avenue. In the dining rooms (below), the specialties of the house were served: "chicken, English chops, and steaks." Music and a "good dance floor" were available. At the time, the proprietor was listed as Evento and Son and the telephone number as Amityville 66. The Alexandra housed race cars for the Vanderbilt Cup Races. It later became known as Shanley's Tavern.

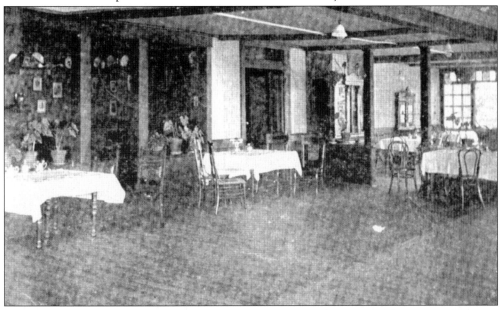

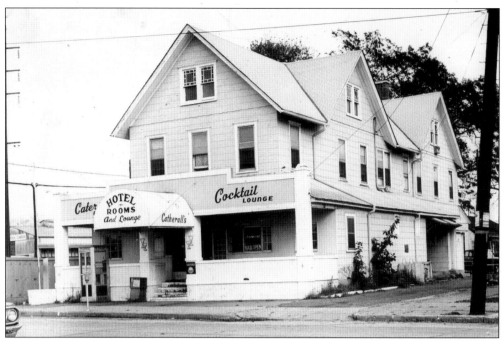

De Marco's Hotel, which later became Catherall's, was located near the Amityville Railroad Station. Al Capone was a frequent visitor while living in Amityville.

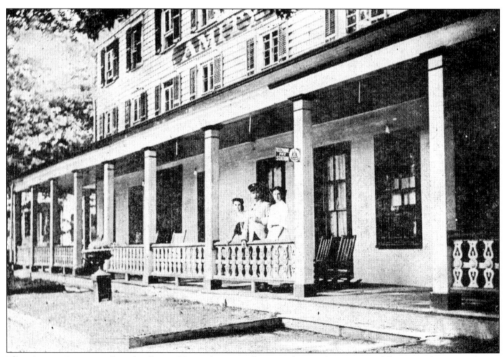

The Amity Inn stood at the foot of Broadway and Merrick Road. B. F. Conklin was the proprietor. The inn hosted participants in the bicycle races that went through Amityville.

Three

HOSPITALS AND
RELIGIOUS INSTITUTIONS

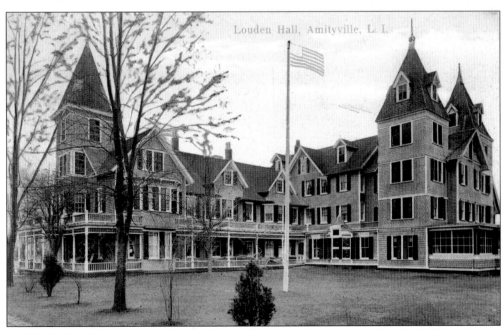

Amityville was home to four hospitals—unusual for a small community. Louden Hall Psychiatric Hospital was established by the Louden family in 1886.

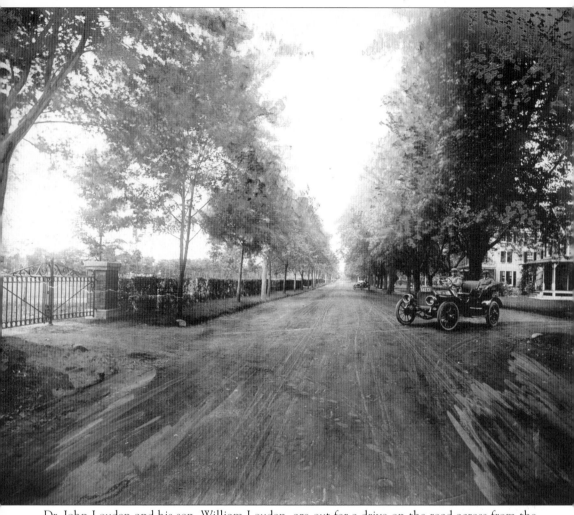

Dr. John Louden and his son, William Louden, are out for a drive on the road across from the Louden farm.

Shown are the grounds at
Louden-Knickerbocker Hall.

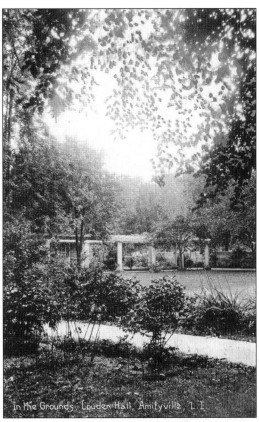

In the Grounds, Louden Hall, Amityville, L.I.

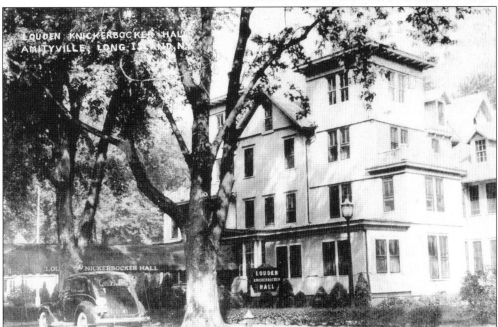

This was the main building of Louden-Knickerbocker Hall. In 1958, Louden Hall became
Brunswick Psychiatric Hospital, a division of Brunswick Hospital.

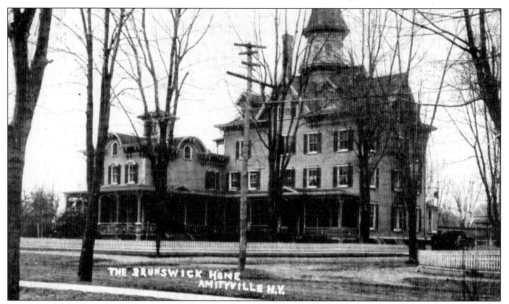

Brunswick Home was a private sanitarium located on Broadway. It is pictured in 1887.

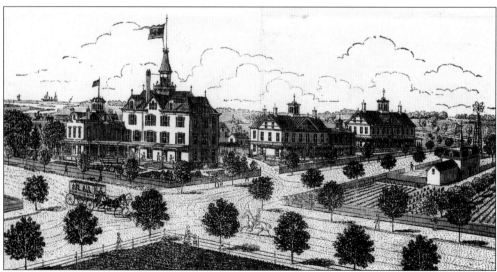

This sketch of Brunswick Home was done by well-known Long Island artist Edward Lange. The home had a farm with livestock on the grounds. In 1940, Brunswick Home burned to the ground and several patients lost their lives in the fire.

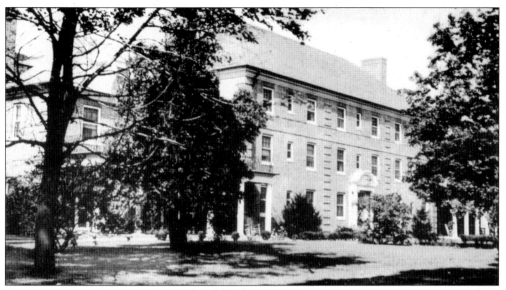

This view shows Brunswick Hospital and Sanitarium in 1926.

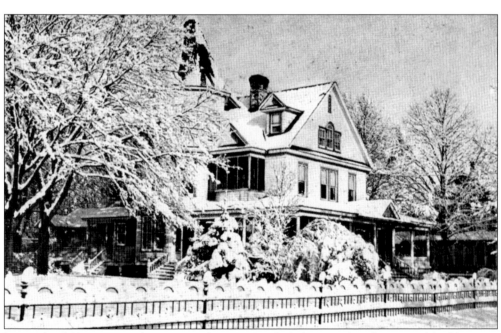

Long Island Home opened in 1882. It became South Oaks in 1952. The original building was razed in 1966.

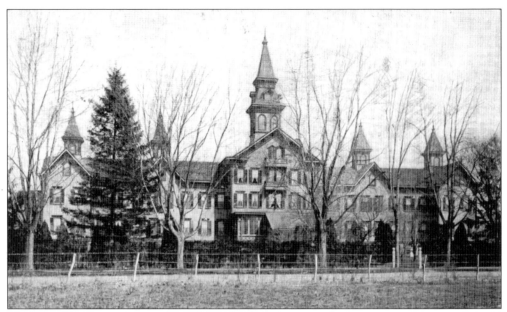

Reed General Hospital opened in 1923 at 52 Park Avenue, which was one of Amityville's old Victorian houses. The telephone number was Amityville 542. The policy of the hospital was never to refuse a patient because of inability to pay for care. The hospital closed in 1941.

Stanton Cottage was a single-occupant home. Renowned English composer Benjamin Britten stayed in this cottage from 1939 to 1941 to escape the London Blitz during World War II. He was the guest of Dr. and Mrs. William Mayer, who were interested in helping artists to safety. Although more of these single-occupant cottages were planned, they were never built.

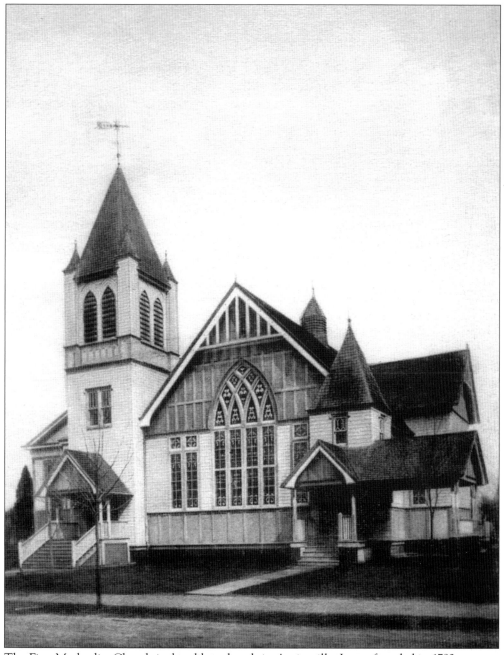

The First Methodist Church is the oldest church in Amityville. It was founded in 1792.

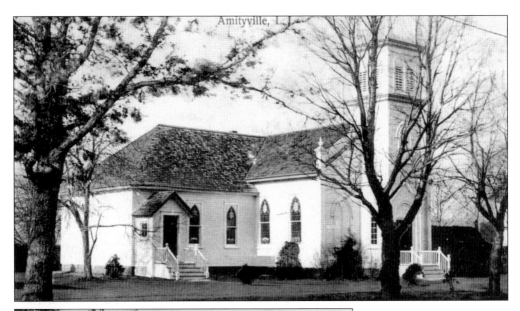

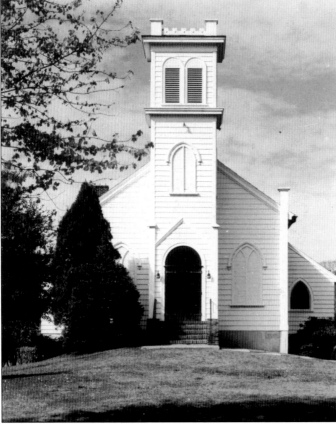

The Simpson Methodist Church was established in 1869 to accommodate the farmers in the northern part of the village. The church was relocated in 1935.

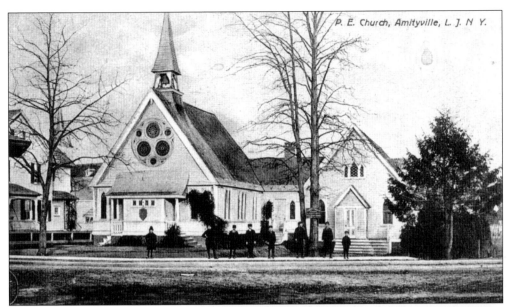

P. E. Church, Amityville, L. J. N Y.

St. Mary's Episcopal Church was formed in 1886, and the church building was completed in 1889. Many decades later, a new front entrance was added when the church was renovated.

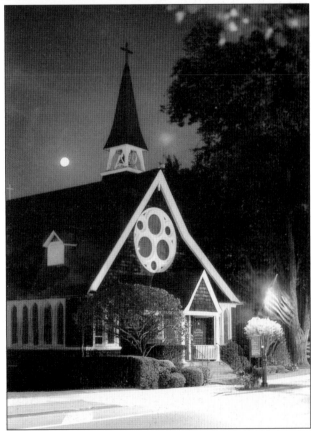

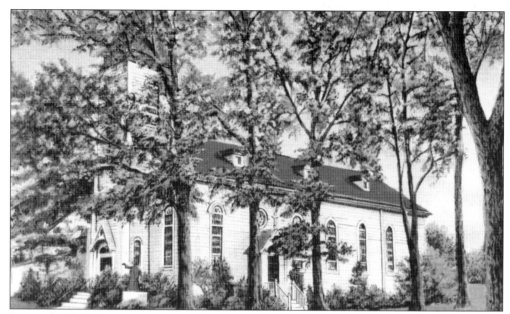

Pictured is St. Martin's Roman Catholic Church, founded in 1897.

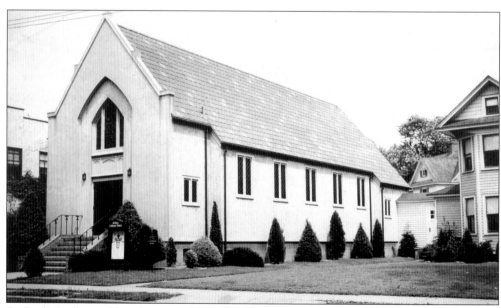

St. Paul's Lutheran Church was established in 1930. The building was completed in 1931.

Four

ORGANIZATIONS

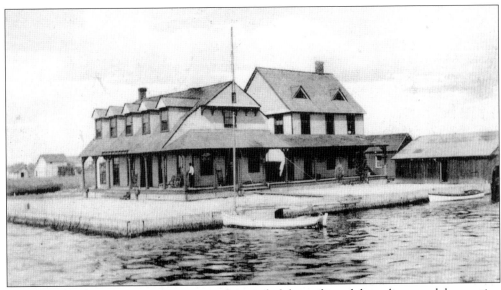

Amityville had numerous organizations: fraternal clubs, sailing clubs, a literary club, sporting clubs, and fellowship clubs. It was a tight-knit community, the people wanted to relate to each other. One of the earliest organizations was the Gilbert Rod and Gun Club. Formed in 1890, the club was dedicated to encouraging lawful sports and social relations. The clubhouse had a fine waterfront location.

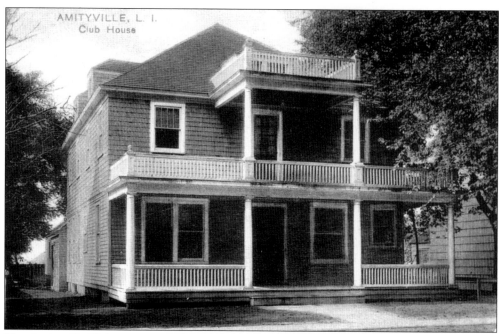

The Amityville Club was organized in 1897 as a social club for men only. Women were permitted to enter the club only on Wednesday afternoon or evening and only when accompanied by a member.

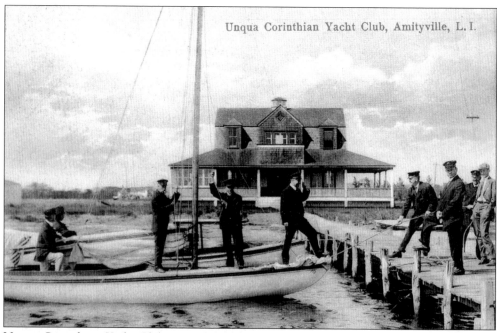

Unqua Corinthian Yacht Club was organized in 1903. The clubhouse was on the waterfront, where its members could enjoy yachting.

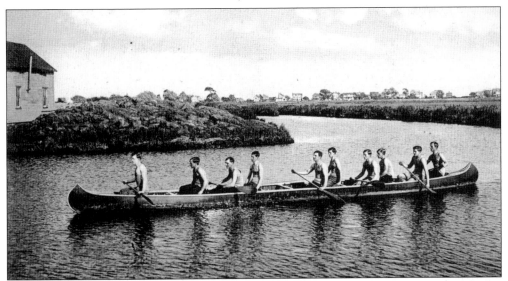

Waukewan Canoe Club was an athletic organization of men who met in the Triangle Building in downtown Amityville. Members used long canoes to paddle the waters of the Great South Bay.

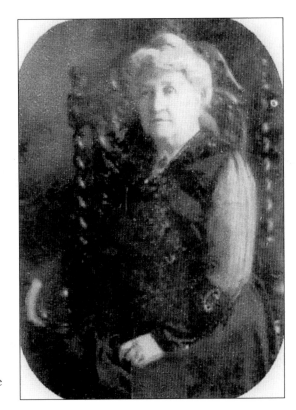

Mary P. Myton organized a literary society in 1904. Members of the society met in private homes. Mary Myton and members of the society helped found the Amityville Free Library in 1907.

American Legion Post No. 1015 was established in 1919. It is shown here in the early 1940s. At that time, bingo was held there every Tuesday night. The building was destroyed by fire in 1960 and was rebuilt at a later date.

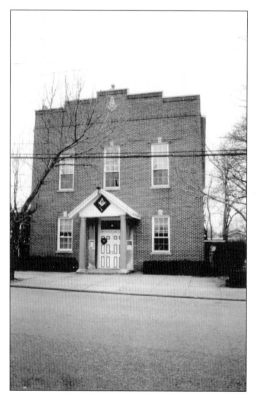

Amityville Lodge No. 977 Free and Accepted Masons was established in 1920. The Masons built their lodge the same year.

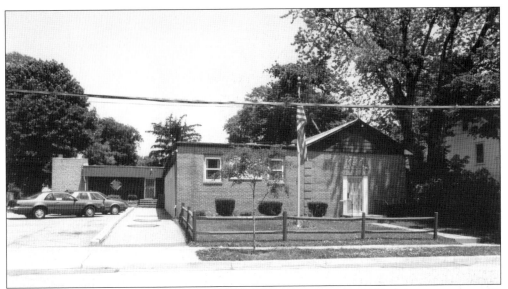

St. Martin's Council No. 2489 Knights of Columbus was instituted in 1923. Active in community affairs, the council received a citation from the U.S. Treasury Department for its promotion of war bonds during World War II.

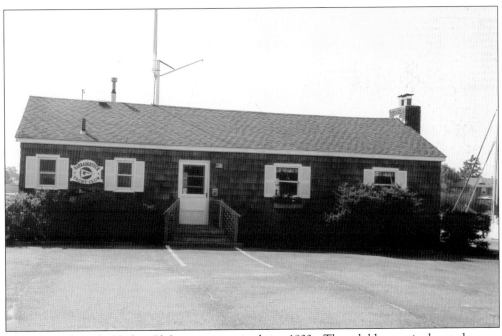

The Narrasketuck Yacht Club was organized in 1933. The clubhouse is located on a waterfront site.

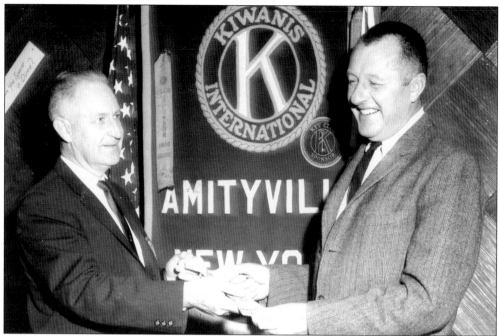

Amityville has a chapter of Kiwanis International. During a *c.* 1963 event, Wesley Powell (left) and William Burns, a former Amityville mayor and state assemblyman, exchange cash for tickets.

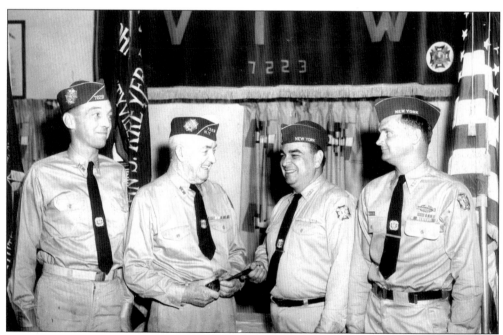

Members of Amityville Veterans of Foreign Wars Post No. 7223 are pictured in uniform. From left to right, they are identified on the back of the photograph as an unidentified Amityville high school teacher, Norman Griffin, and high school teachers Benjamin Kurland and Ralph Forman.

Five

BEACHES, PARKS, AND CEMETERIES

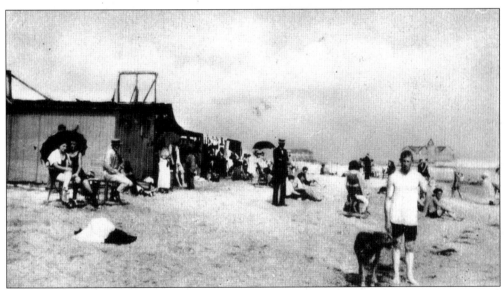

The community of Amityville made every effort to keep open space for the enjoyment of its residents. Families gave land for public parks and preserves and left behind cemeteries. Because of its location on the waterfront of the Great South Bay, beaches were an important site of recreation. O'Brien's Beach, also known as "Denny's Ocean," was run for profit by Dennis O'Brien. It was a private operation, but members of the public could buy a season pass or pay a small fee per day to use the beach and a locker.

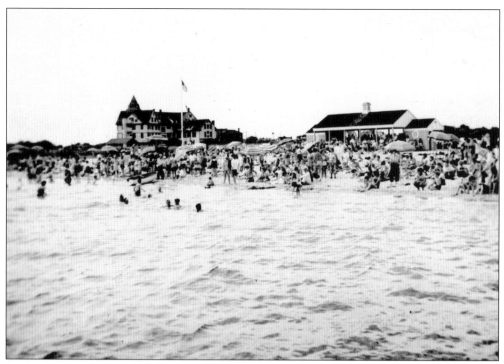

Amityville Beach was officially opened to village residents and hotel guests in 1940. The site was formerly part of the Alfred G. Vanderbilt estate. On opening day, a crowd of 500 attended the ceremony.

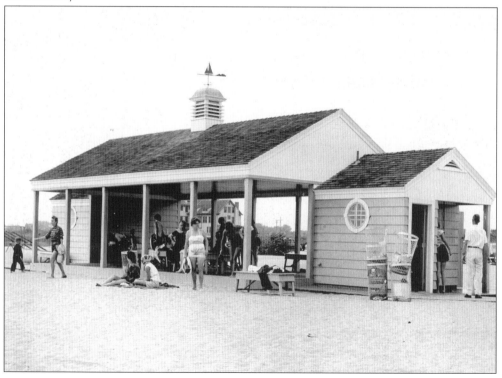

Avon Pond was established in the 1920s on the site of the former Ireland Mill Pond. An early home (below) is reflected in the waters of the pond.

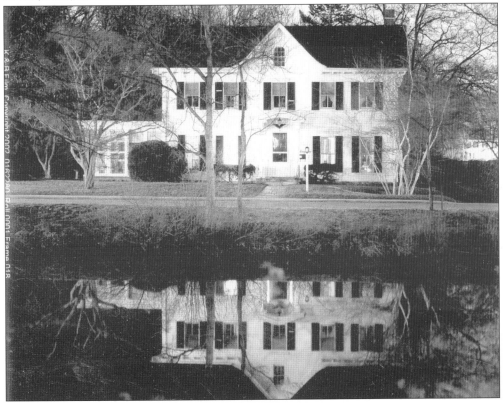

The icehouse that served Amityville before refrigeration once stood where Peterkin Park has been developed. The site had a pond and a stream that flowed from it to Great South Bay. The park was named for Walter Peterkin, a gentleman who left a large sum of money to the village.

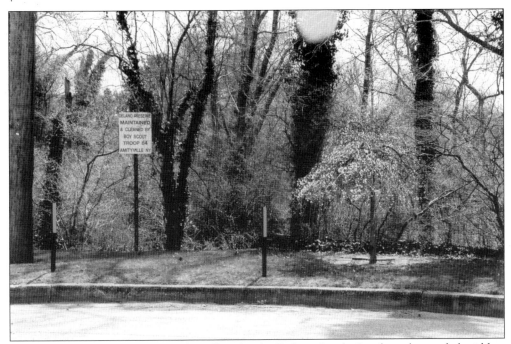

The Delano Preserve was left to the village by the Delano family. It is heavily wooded and has been left in its natural state. The sign states that the preserve is "maintained & cleaned by Boy Scout Troop 84 Amityville NY."

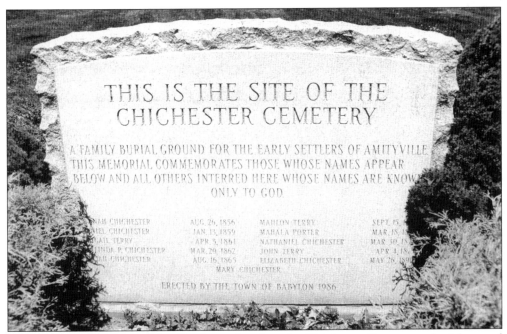

Located on the property of the Chichester family is the Chichester Cemetery, a burial ground for early settlers of Amityville. The names of those buried here include Chichester, Terry, and Porter. August 26, 1856, is the earliest date inscribed on this monument, which was erected by the Town of Babylon in 1986.

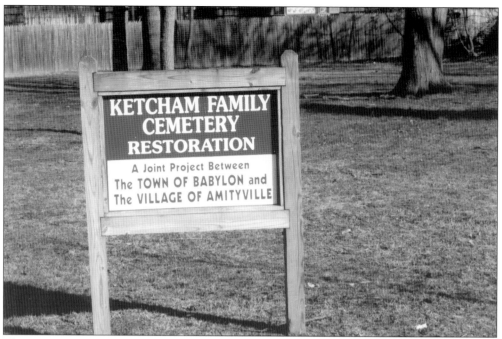

The restoration of the Ketcham Family Cemetery was a joint project, conducted by the Town of Babylon and the Village of Amityville. The burial ground is located on the property of the Ketcham family.

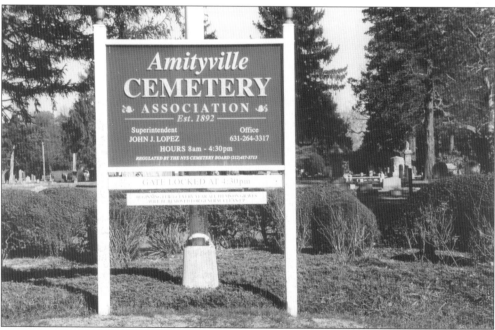

Established in 1892, Amityville Cemetery is located north of the village. It is open from 8:00 a.m. to 4:30 p.m.

Six

SCHOOLS

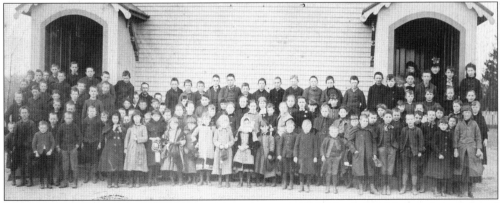

The original Amityville school was in a private home in 1815. Members of the community hired a teacher, whose pay was his room and board in the house in which he lived. The first public school was formed in 1826. This photograph, the oldest known one of an Amityville school, shows the student body in front of the 1872 school. The building was a four-room schoolhouse.

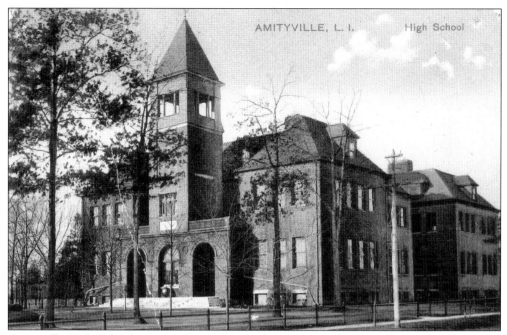

Amityville High School is pictured in 1894. At the time, it had only six high school students. After 1924, the building became an elementary school.

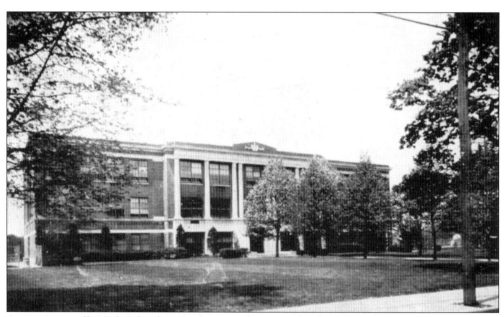

A new Amityville High School was built in 1924 because school enrollment had increased. Students also came from the neighboring communities of Copiague, Massapequa, Seaford, and Wantagh.

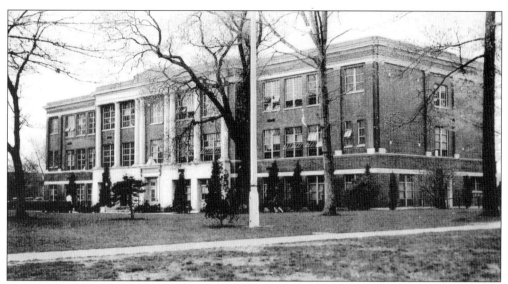

Amityville Public School was built in 1932 to serve the growing population. It had classes for students through the ninth grade.

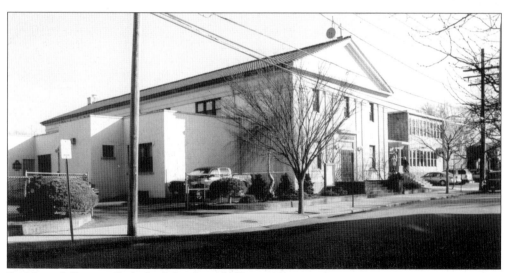

St. Martin's Roman Catholic School was built in 1921.

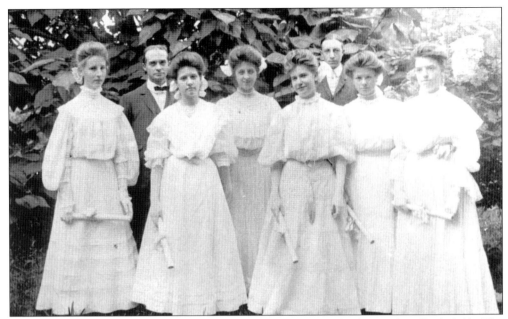

Members of the Amityville graduating class of 1905 pose with the teacher (back left). The president of the class was Enid Bliss.

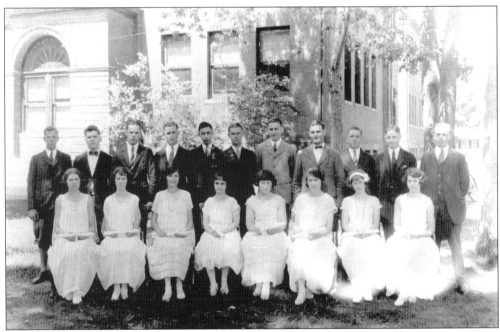

The last class to graduate from the original Amityville High School building was the class of 1924.

Seven

PARADES

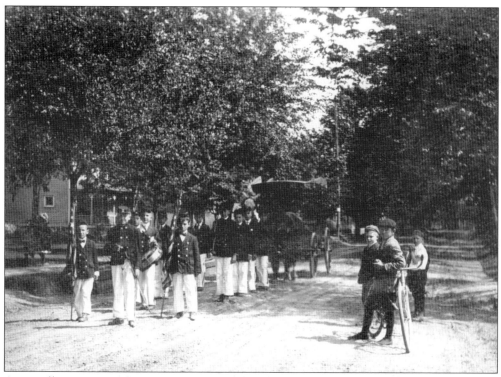

Amityville is a spirited community that enjoys celebrating, and parades are a good way to celebrate. Units for the parades always assembled at the Triangle Building. Waiting for the first Memorial Day parade to begin around 1905 are members of the Amityville Cadet Corps.

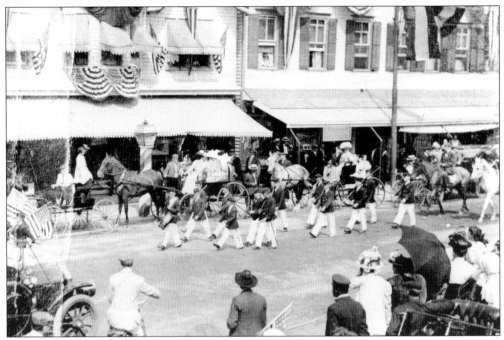

The Amityville Cadet Corps parades through town in 1914.

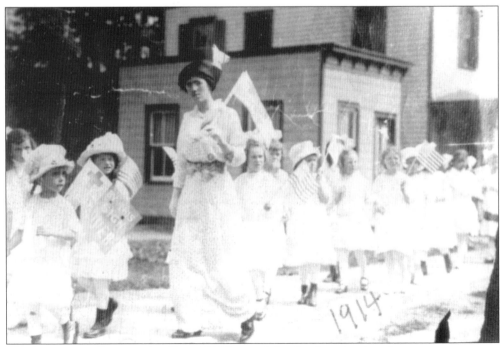

The Anniversary Day parade of June 1914 featured the Sunday school students.

Ma Baylis, a prominent resident, takes part in the Anniversary Day parade, held on June 10, 1927.

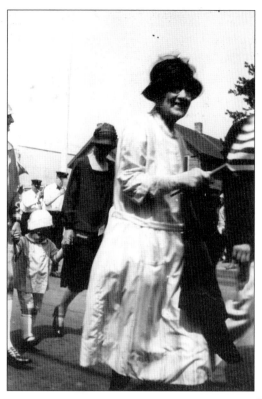

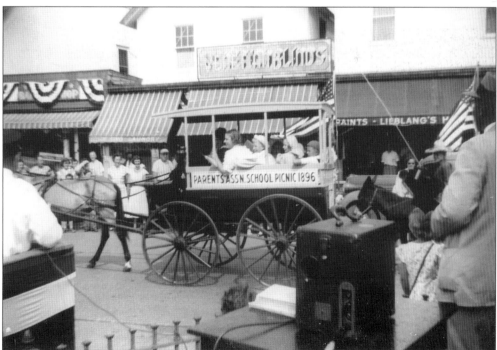

Amityville celebrates its bicentennial in 1944 with a parade. The horse-drawn carriage represents the Parents Association School Picnic of 1896.

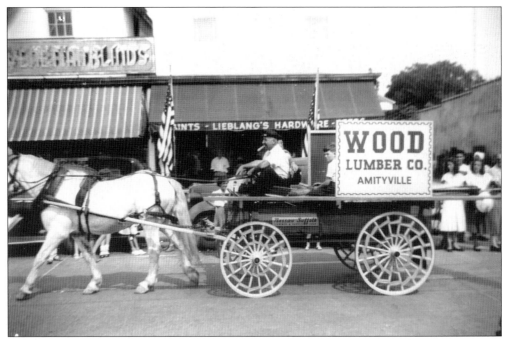

A wagon advertises the Wood Lumber Company in the 1944 bicentennial celebration.

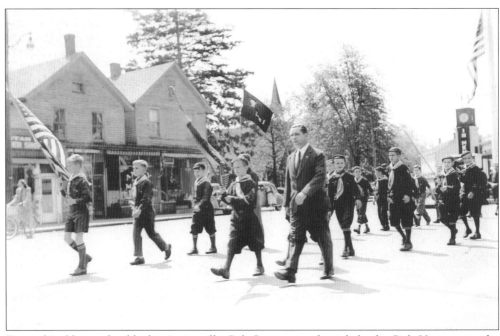

Dressed in blue and gold, the Amityville Cub Scouts march with leader Bob Homans in the 1940 Memorial Day parade.

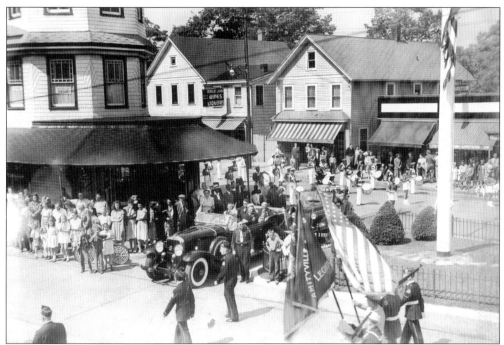

Almost everyone in town has arrived at the Triangle Building for the 1937 Memorial Day parade.

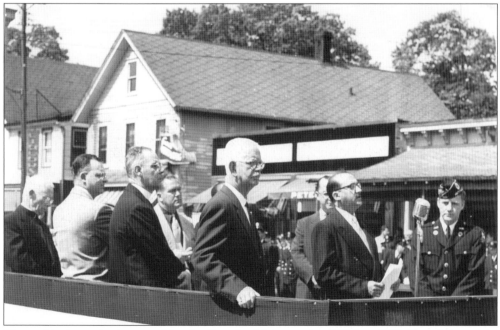

Pictured is the reviewing stand for the Fourth of July parade of 1953 or 1954. From left to right are Rev. Bayard Goodwin of St. Mary's Church; James A. Caples and Ernest Barker, both village trustees; unidentified; Rev. Edmund Bohm of St. Paul's Church; Mayor Herbert Carpenter; an unidentified rabbi; and unidentified.

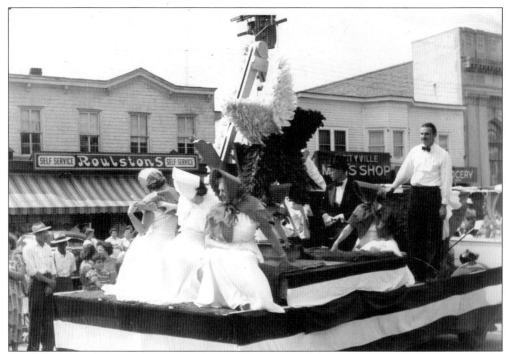

The Order of the Eastern Star entered this float in the Fourth of July parade.

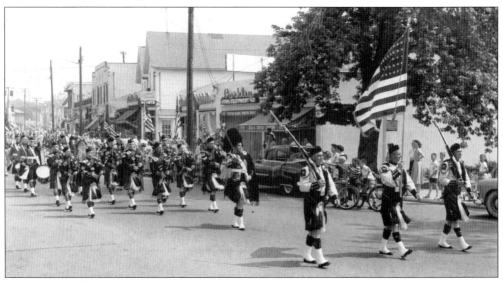

Pipers parade down the street in July 1955.

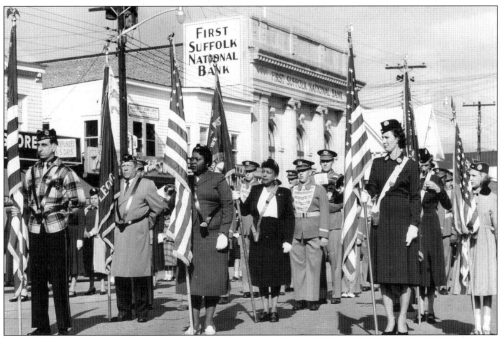

The 1955 Veterans Day parade stops in the center of town.

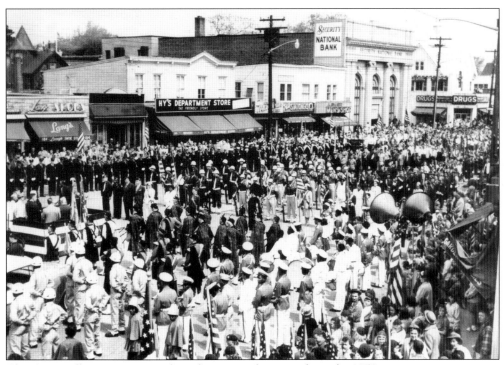

The Amityville community gathers downtown for a parade in the 1950s.

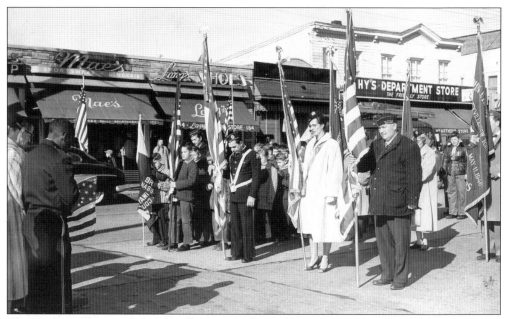

The Veterans Day parade halts in the center of town by Mae's Sportswear and Lingerie, Lang's Shoes, and Hy's Department Store in 1957.

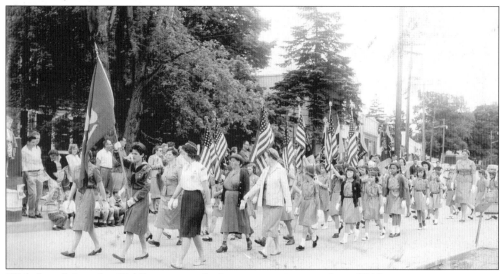

With flags flying, the Girl Scouts march along in a spring parade in 1960.

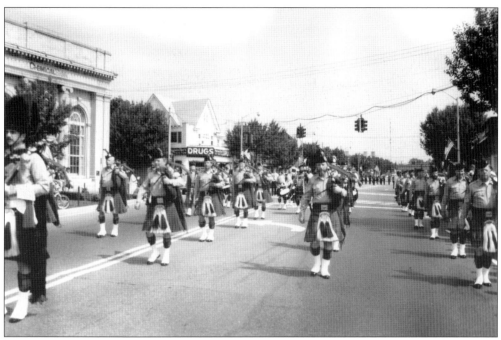

The American Legion Kilties take part in a Fourth of July parade passing by Phannemiller's Drugs and Chemical Bank.

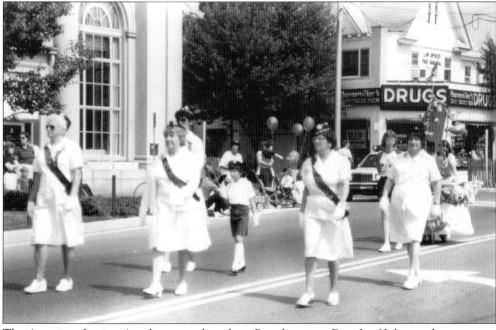

The American Legion Auxiliary marches along Broadway in a Fourth of July parade.

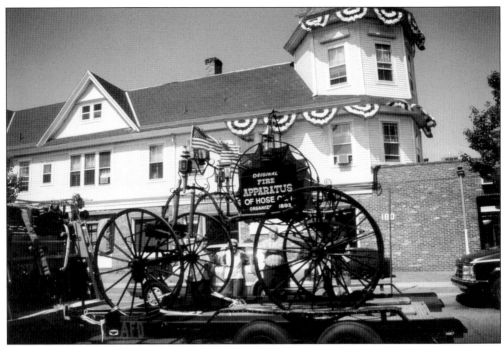

On display in a summer parade is the original fire apparatus of Hose Company No. 1, which was organized in 1893.

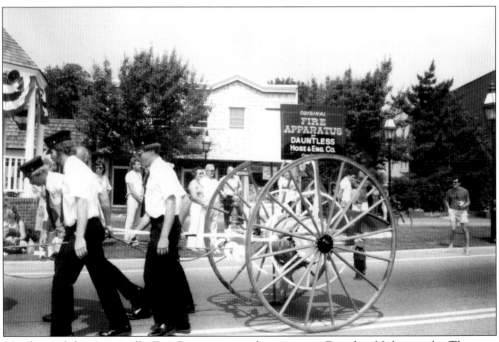

Members of the Amityville Fire Department take part in a Fourth of July parade. They are pulling the original fire apparatus of Dauntless Hose and Engine Company.

Eight

THE WATERFRONT COMMUNITY

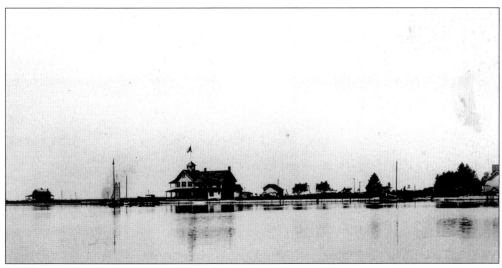

Recreation played an important role in the life of the residents of Amityville. Commercial fishing, duck hunting, clamming, and shipbuilding were other pursuits. This view of the creek was taken looking westward.

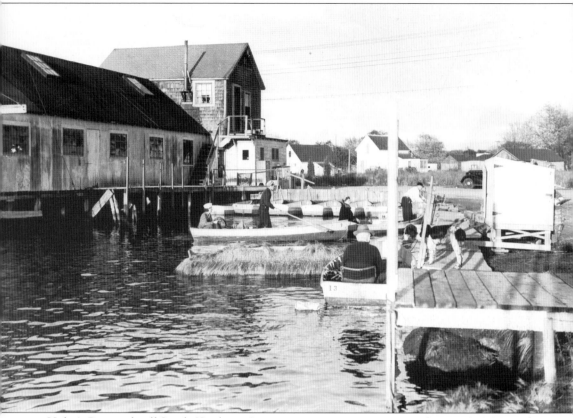

Hulse's Boatyard, off South Ketcham Avenue, is active on an autumn day in 1946. Note the blind (foreground) for duck hunting.

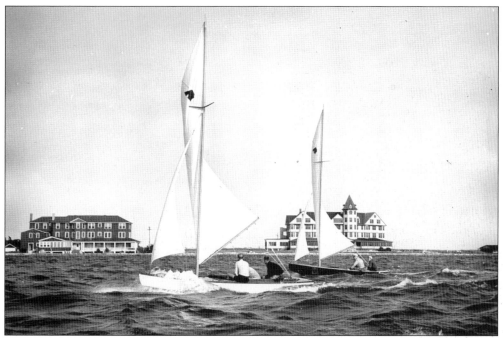

Narrasketuck sailboats race on Great South Bay. On the shore are the Hathaway Inn (left) and Hotel New Point. The Narrasketuck sailboat was designed by Wilbur Ketcham. The Ketchams were well-known boatbuilders in the area.

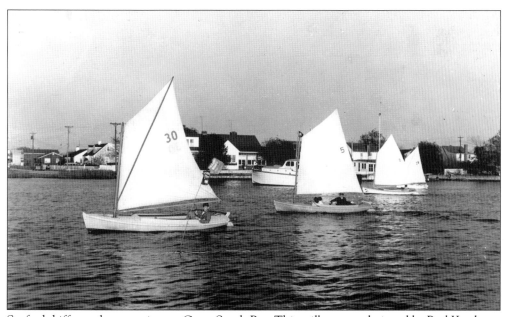

Seaford skiffs are shown racing on Great South Bay. This sailboat was designed by Paul Ketcham.

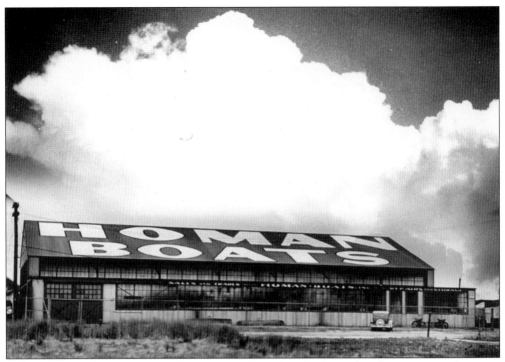

Many boats were built at Homan Boats. The plant offered sales and trades, repairs and storage. Eventually the plant became a hangar for seaplanes that were built there.

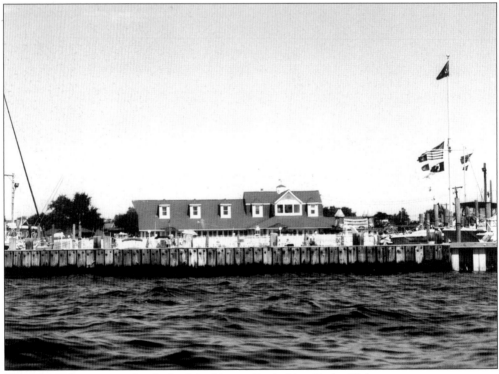

The tide washes against the dock of the Unqua Corinthian Yacht Club.

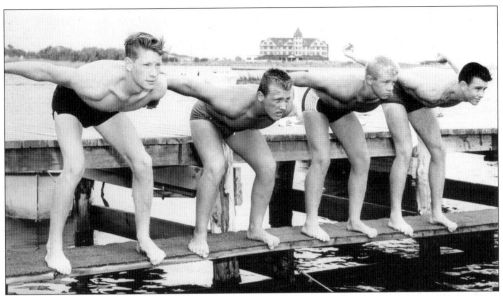

Four swimmers await the signal to dive. They were contestants in an Unqua Yacht Club swimming race held each August. In the background is the Hotel New Point.

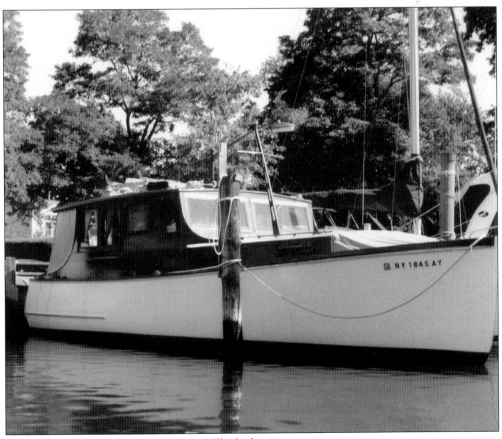

A vintage boat is tied up at the Amityville dock.

Boathouses line the creek.

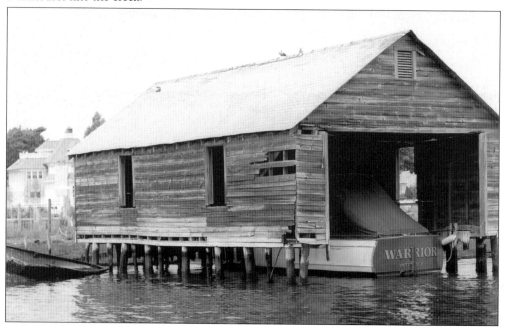

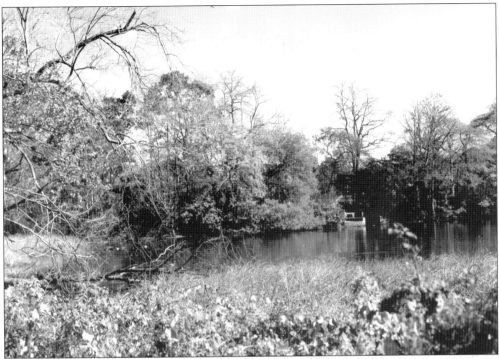

Ireland's Pond was the water source for the gristmill. The mill opened in 1790 and closed in 1916.

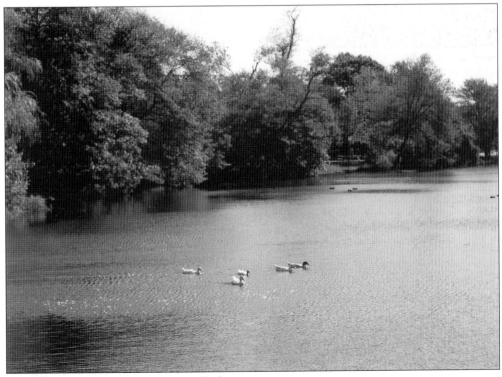

Avon Lake is a favorite spot for waterfowl.

Avon Lake is one of the inland waterways in Amityville. The lake is a favorite spot for waterfowl.

Shown is the remaining part of the millrace for the gristmill.

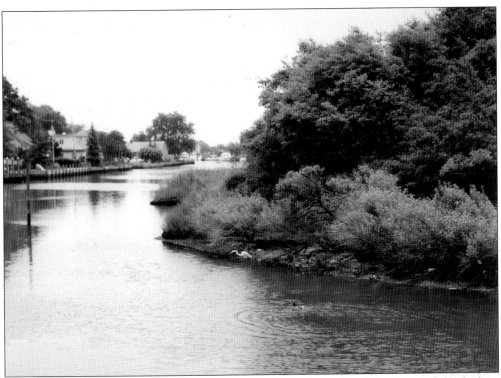

Ketcham's Creek meanders out to the Great South Bay. Notice the white egret and the ducks.

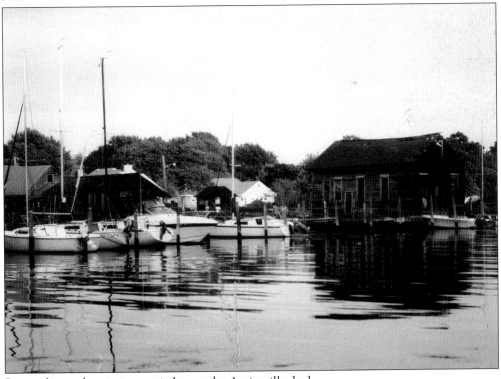

Boats of several varieties are tied up at the Amityville dock.

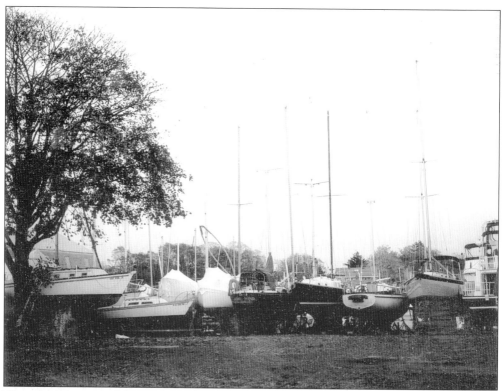

These boats are out of the water, in dry-dock.

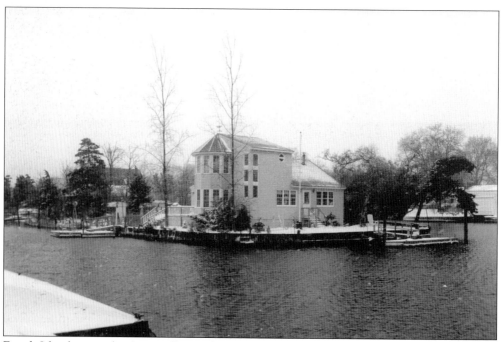

Enoch Island sits in the Amityville Creek. The island is accessible only by boat.

Nine

HOMES

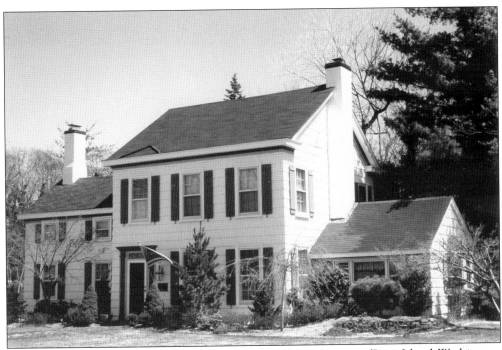

"George Washington *Supped* Here." On April 21, 1790, during his tour of Long Island, Washington "dined at one Ketchums," which he described in his diary as a "very neat & decent public House." Washington's repast was taken at Zebulon Ketcham's Inn, then located on Merrick Road. In the 1940s, the inn was transported by barge down Ketcham's "Crik" and reestablished as a residence on Bayview Avenue at Purdy Lane. Washington's portrait graces the mantel over the dining room hearth to this day.

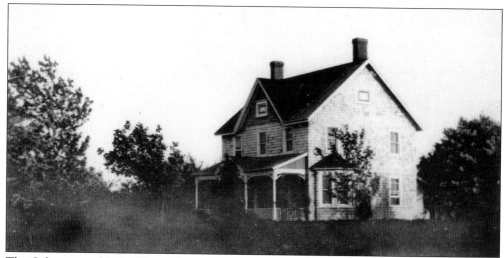

The Solomon and Lida Wanser homestead stands at Coles and Richmond Avenues. A duck farmer and bay man by trade, Wanser was well respected and served as a village trustee and commissioner in the late 1890s. Before constructing their shingled dwelling with its broad porch and lacy detail, the Wansers lived in a farmhouse. Upon learning that his wife was with child, Wanser declared, "If you have a daughter, I'll build you a bigger house." Daughter Cora was born in 1888. The house was completed within a year.

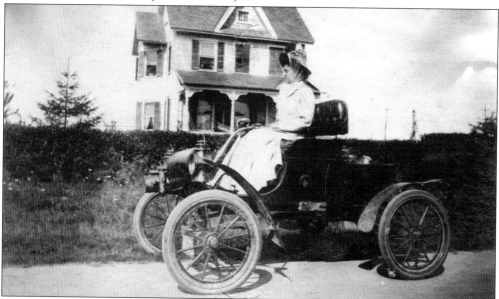

Accepting a healthy offer for his Farmington farm, Eugene Watkins De Le Ree moved to Amityville with his wife, Jane, in 1903 to be near his sisters Adella Spragg and Lida Wanser. Along the dirt portion of Richmond Avenue at Morris Street, he built his home, which was called the Corner House. The simple gabled farmhouse, with stylish decorative post brackets, stood at the edge of the meadow like a solitary sentry overlooking the unsettled marsh. De Le Ree harvested salt hay and became a boatbuilder, fisherman, and land entrepreneur, acquiring a large tract for investment. He ultimately dredged the De Le Ree Canal, a navigable inland waterway, and developed the land along its banks with Alvah W. Haff, a land neighbor. This 1908 photograph shows the De Le Ree house with daughter Carrie seated in a curved dash Oldsmobile.

As a reaction against elaborate Victorian architecture, the American public embraced the simple and symmetrical style of the Colonial Revival style. The Patterson House, built around 1917, reflects the patriot fervor of the war period and echoes America's original Colonial period with its clapboard facade, gabled roof, and centered portico. Ken Darling, one of 33 children of the natty well-dressed Oliver Darling Sr., married the Patterson's daughter in 1929. Oliver, a successful stockbroker, resided in two homes on nearby Richmond Avenue to house his crew.

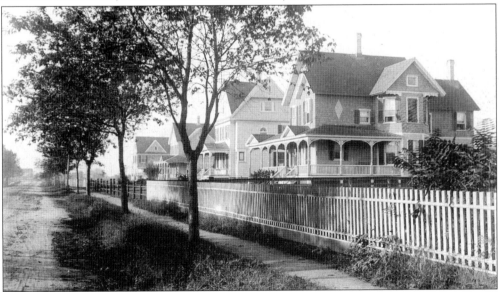

Development along Ocean Avenue went into high gear in the late 1800s. Gracious cottages were built along the village thoroughfares. The Woodman house (right), shown around 1895, represents a typical Queen Anne, replete with ornamental spindles and brackets, wraparound porch, and double-tiered bay. Builders used mass-produced precut architectural trim to create fanciful houses. Municipal planning is evident by the neat row of planted trees running the length of the road.

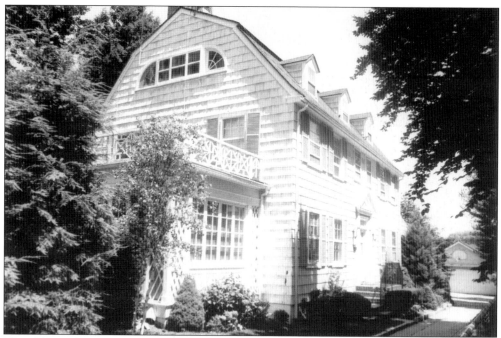

This famous house possesses classical elements of the Dutch Colonial design including a gambrel roof, shingled siding, and a side entry. The Dutch style recalls an early Colonial building technique, in which houses were constructed laterally to accommodate narrow lots. Built around 1925 by Jesse Purdy, a premier house builder, this house lies on the Amityville River, nestled next to the Ireland homestead. Recently associated with a book and movie, this house is better remembered as the house with Amityville's smallest lawn.

In 1890, E. C. Smith of the "city of Brooklyn" purchased land on the west side of Ocean Avenue. The deed mandated that "a first class frame dwelling with a value of no less than $2,500 be built within one year" and that the property "revert back" to the seller if the house was not built. The house was completed ahead of schedule by Erastus Ketcham, a prominent Amityville builder. Covenants were means of private zoning and often contained forfeitures as a way to regulate development.

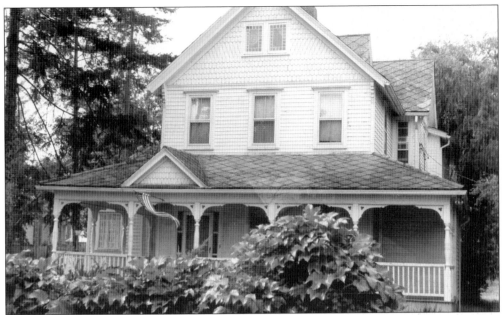

Will Rogers—a cowboy, humorist, Ziegfeld Follies star, and everyday philosopher—called Amityville home in the early 1920s. An astute commentator, Rogers "never met a man he didn't like." He lived in this 1895 Queen Anne home on Clocks Boulevard, across from vaudevillian Fred Stone. It was here that Rogers dove off Stone's dock into the Narrasketuck Crik and broke his neck. Long days of rest in Amityville sharpened his wit and his roping. A regular at Losi's Confectionery, Rogers could be seen chatting with neighbors, exclaiming, "All I know is what I read in the papers."

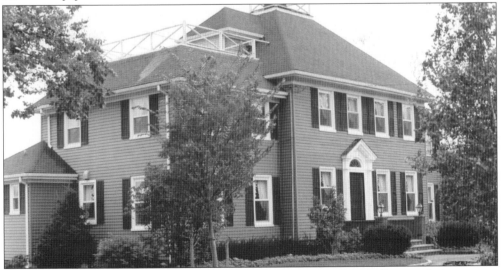

Surrounded by myth and legend, sharpshooter Annie Oakley (1860–1926) enjoyed a long career as a vaudeville entertainer and friend to fellow Amityvillians Will Rogers and Fred Stone. In the early 1920s, she rented this home on the east side of Ocean Avenue, built in the American Foursquare style. In the late 1920s, the house was altered by removing the porch and adding symmetrical wings. Commanding a prominent place along the river, the house lies atop Bennett's Hill, a slight rise marking the beginning of the salt hay meadows.

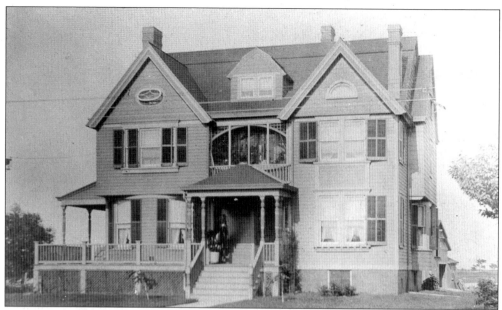

Built around 1894, Griffing House is an eclectic Victorian on the east side of Ocean Avenue, on the Amityville River. Griffing, a Manhattan hardware store clerk, was presumably a man of independent means. Prominent among the home's features are the incongruent oval and half-moon windows perched in each gable and the screened-in second-story porch. The distinctive bowed dining room wall, three-sided wraparound porch, and extensive trim made this residence a favorite among strollers and roving photographers.

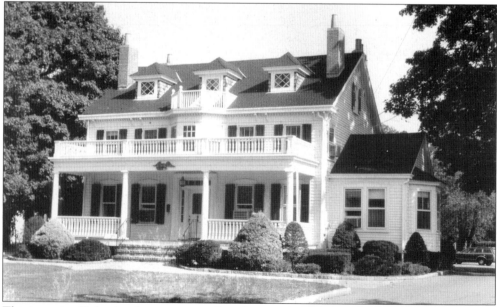

This imposing Federal-style structure on Broadway, with its distinctive second- and third-story balustrade, was constructed in 1850 by Treadwell Ketcham. Ketcham was a millionaire financier who reveled in the glamour of New York City. The columns, plinths, and dentil moldings reflect the Greek Revival architectural influence of the day. The front porch was built in 1880 to replace a rounded porch that was reinstalled at the rear.

The Ritzheimers were noted piano manufacturers. In 1930, Philip Ritzheimer built this grand home on Bayview Avenue. Its great lawn, clipped gable, and chiseled arched windows and doors are characteristic of the Richardson Romanesque style, which celebrates the strength of American commerce. It remains one of Amityville's most prominent residences to this day.

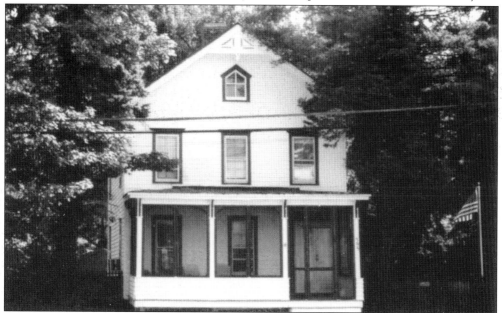

The Totten-Purdy House was built in 1850 by Elbert Carmen for his daughter Aramantha. The home possesses several delightful mid-19th-century-style features such as an ornamental gable bracket, gothic attic window, and double oak doors. The Purdys were early settlers, well known in the farming and building trades, who contributed significantly to Amityville's development and prosperity.

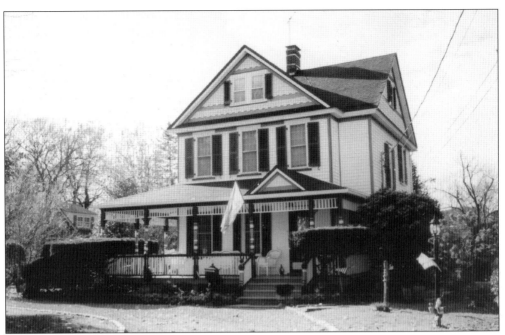

The c. 1899 Frank W. Smith House was the residence of one of the original village incorporators. Frank W. Smith operated a dry goods shop in the old schoolhouse on Park Avenue. This late-Queen Anne–style home—with sawtooth wood siding, turned posts, and running upper balustrade—was moved from Union Avenue to Barberry Court in 1909.

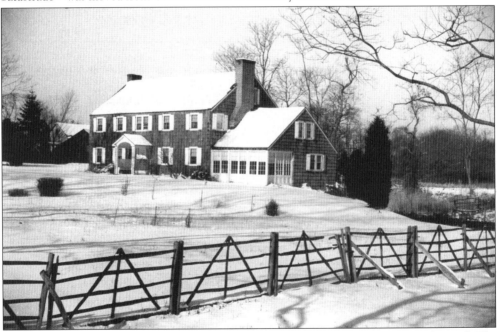

Built in 1927, the Haight House stood on the banks of Ireland's millpond on Merrick Road. The grist- and sawmill operated between the 1750s and 1915. Over the generations, the Ireland family played a central role in the village's development. This influence is best illustrated in the name of Amityville itself, having been taken (some believe) from Samuel Ireland's sloop, the *Amity*.

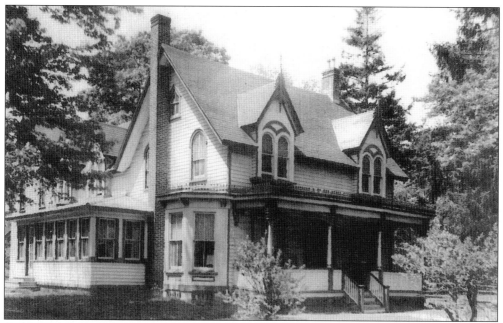

A. H. Saxton was a New York City merchant and trade consultant to Pres. Grover Cleveland. This *c.* 1880 house, located on Broadway, later became part of the Brunswick Home. Highly stylized, it boasts a distinctive front porch and bay with iron cresting running along its roof. The arched second-floor windows compliment the steep dormers with their decorative gable spindles and brackets.

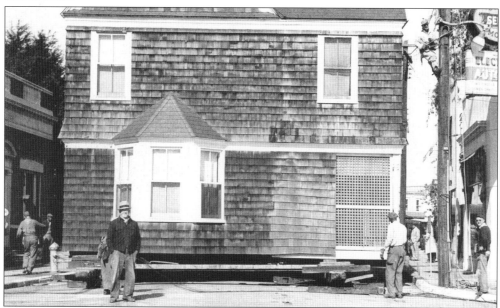

The *c.* 1886 Hurd Homestead was moved in the late 1930s from its original Broadway location to Oldfield Avenue. Placed upon logs and rolled through the streets, homes were often moved to other village locales to make way for development. William Hurd, a dentist, was the father-in-law of William Skinner, a civic-minded and farsighted businessman. Skinner was elected the first village trustee in 1894.

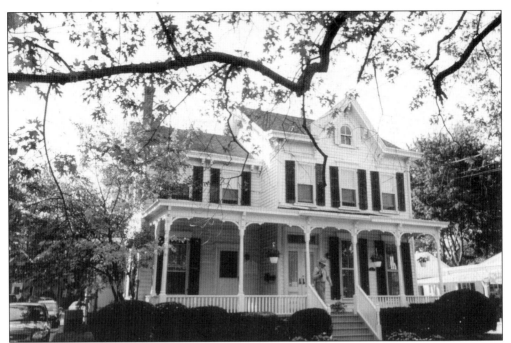

Built around 1860 by John K. Smith, this farmhouse stands in the heart of the Village Historic District. The oak double doors, turned porch posts, and weighty eave corbels were popular vernacular building details that embellished the homes of farmers, sea captains, and prosperous merchants.

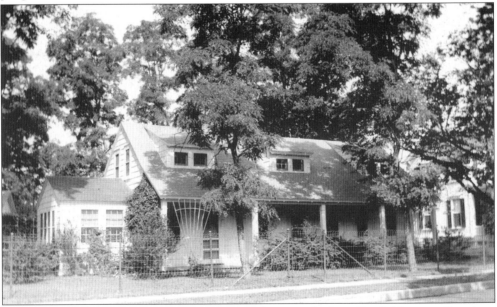

Known as Dutch House because of its Old Dutch elements, the Jesse Smith House on Broadway is the oldest house in Amityville still located on its original site. This landmark was built in 1792 and was the site of the Huntington Town Board meeting in 1793. Amityville, then know as Huntington South, was part of Huntington, which under a royal patent, extended from the Atlantic Ocean to Long Island Sound.

Renowned Long Island artist Alice Virginia Kettelhack (1917–2003) lived in this quaint cottage on Cottage Place until her death. An elegant and gifted woman, she painted south shore water colors that are highly regarded. This lovely shingled cottage set off in the woods is one of Amityville's most unique inspirations.

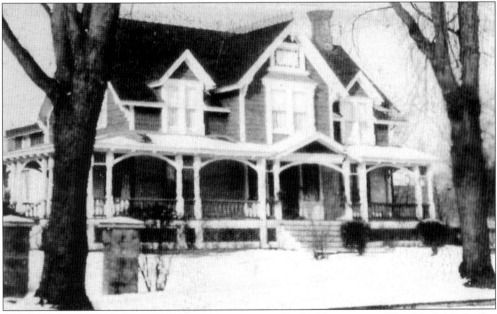

Built in 1823, this Greek Revival structure was originally the Huntington–West Neck Methodist Church on Merrick Road. It was moved twice and came to rest at the corner of Broadway and Cedar Street. The ornate arched porch with coupled columns was added in 1886, when the church was converted to a residence. The chimneys still exhibit receded brick crosses, echoing the building's ecclesiastical past.

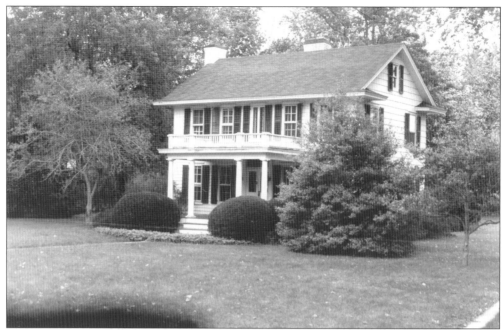

George A. Brown was a highly respected Amityville school principal. He resided in this Georgian-Federal residence, built around 1850. A porch lies above the front portico, supported by classic Tuscan columns. The school district lines were redrawn to include this house to assure Brown's tenure.

America's foremost poet was born in Huntington and worked as a schoolteacher to kick-start his poetry and journalistic career. Walt Whitman (1819–1892) occupied this house while teaching in the Babylon schools. Known as the Walt Whitman House, it was built around 1835 and was later moved to the east side of Park Avenue, amidst the leaves of grass.

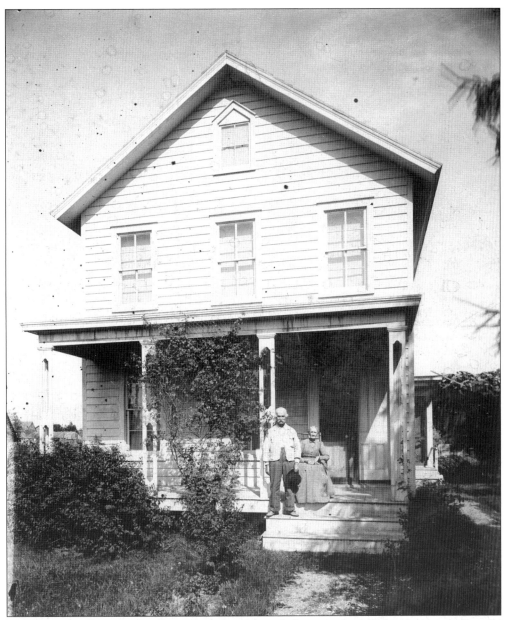

Emma Day and her husband pose on the steps of their unadorned farmhouse. Amityville consisted of numerous truck farms that cultivated corn, hay, flowers, vegetables, and strawberries for sale in city markets. This *c.* 1860 house was situated close to Park Avenue and Cedar Street. Like other small farms, the fields were planted in the back of the house on a long narrow lot.

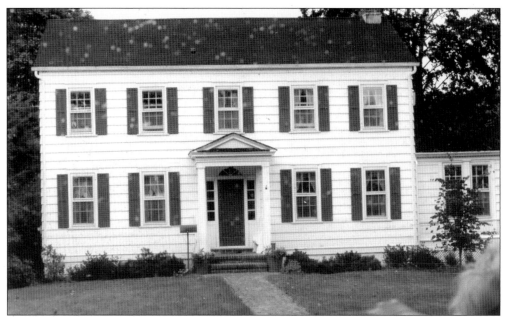

Henry Gladstone, famed WOR radio broadcaster and United Nations correspondent, lived in this home from the 1940s to the 1950s. It is located on Ocean Avenue, across the street from the home of fellow radio personality John Gambling. Built in 1925 and originally used only as a summer home, the Gladstone house is a mixture of Federal and Colonial Revival styles, including a sidelight doorway, six-over-six windows, and an entrance pediment.

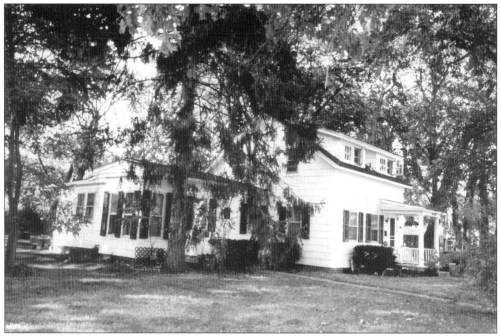

Platt Ketchum Sr., a fisherman and farmer, constructed this Greek Revival cottage on Broadway in 1830. The casement eyebrow dormers above the dentil-trimmed porch were added to accommodate Platt and Orpalett Ketchum's two youngest daughters, who arrived in 1845.

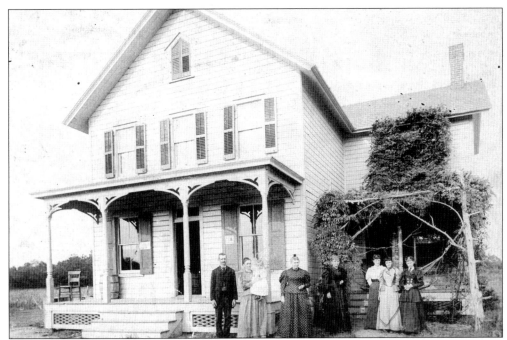

Shopkeepers, artisans, and practitioners often used the first floor of their residence as a store or a place to conduct their craft. Henry Floyd Haff's general store, pictured in 1896, was located on North Broadway and featured a full array of goods from fruits to fabric. Almost all families had a kitchen garden growing out back. From left to right are Henry Floyd Haff, Catherine Carman Haff holding Albert Thomas Haff, Grandmother Carman, Grandmother Haff, unidentified, Olive Haff, and unidentified.

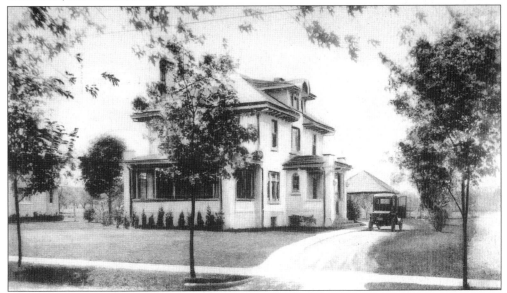

The H. H. Tinkam House, pictured around 1920 on Bennett Place, possesses all of the distinctive features of Spanish Mission–style architecture including stucco siding, large square pillars, an arched dormer, extended eaves, and a grand entry. H. H. Tinkam was a prominent personality and owner of Nassau-Suffolk Lumber Company.

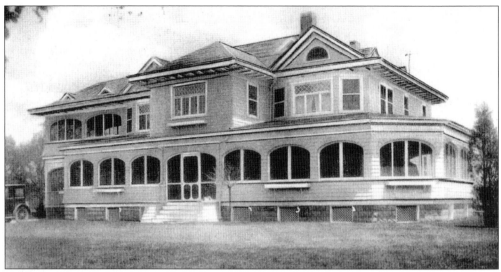

Fred Stone (1873–1959) had a theater and film career spanning 50 years. He co-starred with the likes of Katherine Hepburn, Gary Cooper, and Henry Fonda. Stone's imposing Shingle-style home—part of his sprawling estate known as the Chin-Chin Ranch—lies along the Narrasketuck Crik across from Will Rogers's house.

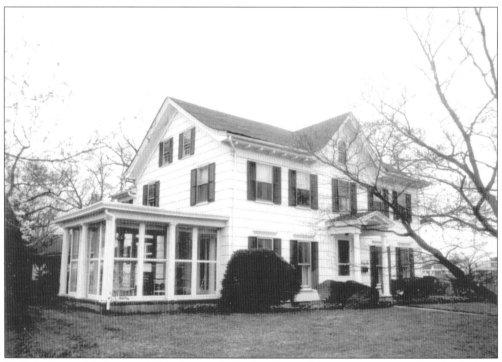

Built by Samuel Ireland in 1840, this noble Gothic Revival home has remained in the Ireland family over the generations. In the late 1950s, it was moved from the head of Ocean Avenue and Merrick Road to the bank of Avon Lake. Joseph Ireland, Samuel's ancestor, fought with Gen. George Washington in the Battle of Long Island.

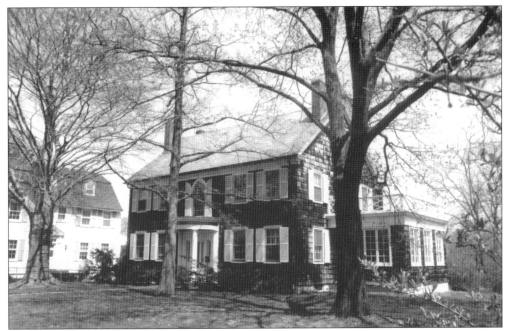

The John E. Ireland *c.* 1928 house is a grand homestead overlooking the Amityville River. The Chippendale balustrade and Palladian window reflect its Colonial Revival style. Ireland, the grandson of the founder of Ireland's Mill, was supervisor of the Town of Babylon and a founder of the Bank of Amityville. He developed Hotel New Point.

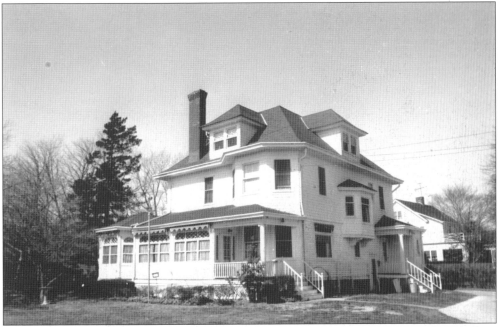

The *c.* 1907 Mortimer Palmer House sits on the site of the former Ocean Point Hotel, at the base of Ocean Avenue and Unqua Place, overlooking the Great South Bay. This majestic homestead captures the essence of late-Victorian architecture, with its full two-sided wraparound porch, porte cochére, and suspended second-story bay at the head of its central staircase.

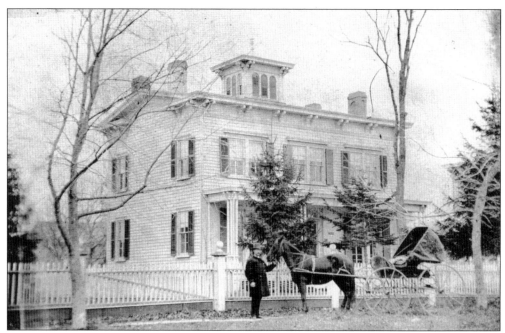

E. Forest Preston was a country doctor who operated from his home, an elegant c. 1850 residence at the head of Richmond Avenue. Preston tended to daily illnesses and delivered babies. Amityville children grew up with the Prestons, including daughter Maude, who became a much-loved schoolteacher.

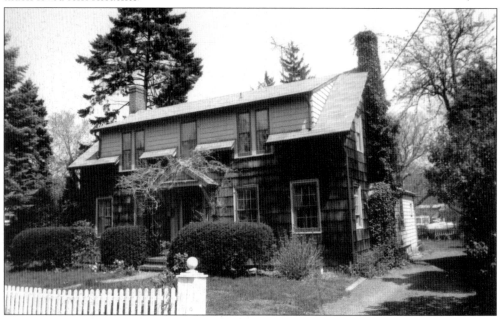

The Dr. George Richmond Home now stands on the east side of Ocean Avenue on the Amityville Crik. Built around 1845, the shingled cottage-style home, with its eyebrowed dormer and wisteria entrance, recalls a simpler time in the village. Alfred P. Sully, a part-owner of the Long Island Railroad, moved this house from Richmond Avenue in 1876 to make way for his larger home.

Ten

INFLUENTIAL PEOPLE AND AMITYVILLE TODAY

Charles F. Delano founded the *Amityville Record* in 1904. The newspaper has been in existence ever since.

William Skinner was originally a summer visitor but soon became a permanent and prominent resident of Amityville. His job was in New Jersey, so he had a long commute to get to his office.

Walter Peterkin donated $37,000 to the village to be used for parks. The Peterkin Park site was chosen because it was one of his favorite spots.

Paul Bailey was the founder of the *Long Island Sun*, a local weekly paper. He also founded the *Long Island Forum* and was the author of several books. During his time he was the postmaster and served in the state assembly.

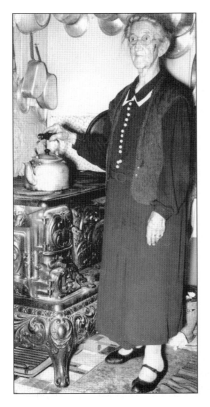

The first Amityville centenarian was Huldah Etta Ketcham. The mother of seven children, she resided in Amityville for 103 years. She stands in her kitchen, with her teakettle on the well-polished stove, a few days before her 100th birthday in February 1941.

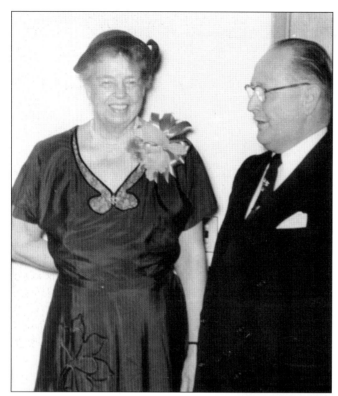

Donald Muncy, Babylon town supervisor, greets Eleanor Roosevelt on the occasion of her visit to Amityville.

Elizabeth Ketcham was familiar to many Amityville residents because she was the cashier at the Amityville Theater for more than 35 years. This photograph bears the date of May 1960.

Three leaders of the Amityville Chamber of Commerce exchange business news. From left to right are merchant William Lieblang, funeral director Benjamin Powell, and lawyer Eugene Blumberg.

Humbert Martin was one of Amityville's mayors. He is pictured with his wife Eleanor on March 1, 1986.

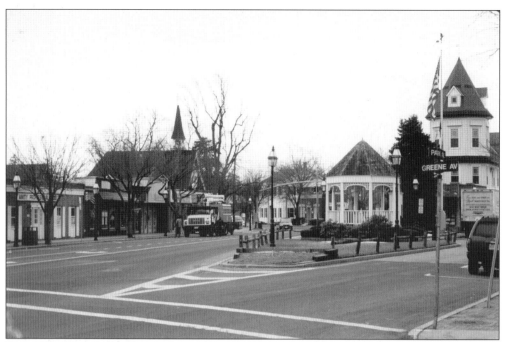

Today the Triangle Building still stands between Broadway and Park Avenue. The building no longer has a watering trough in front, but it does have a handsome gazebo. This picture was taken from the corner of Park and Greene Avenues.

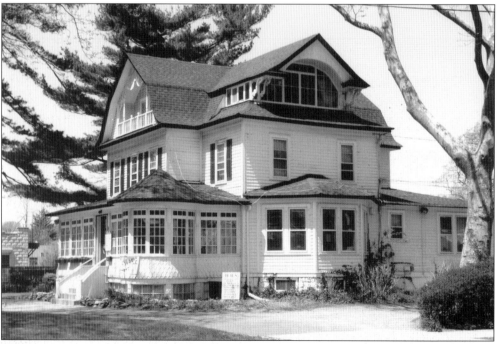

Like many other older homes, the Martin House is now used for business. H. B. S. Jewelers is located here, and its sign says, "Gold & estate jewelry, silver & gifts, custom orders, stringing, repairs, remounts, appraisals, buy & sell."

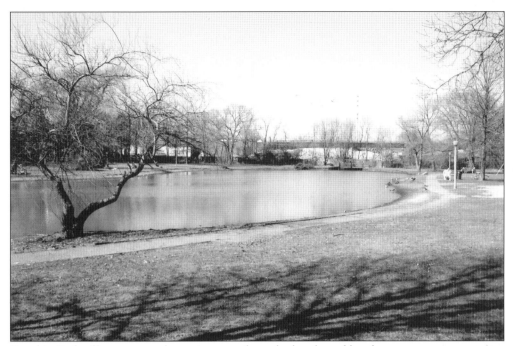
Peterkin Park offers peace and serenity away from the hustle and bustle.

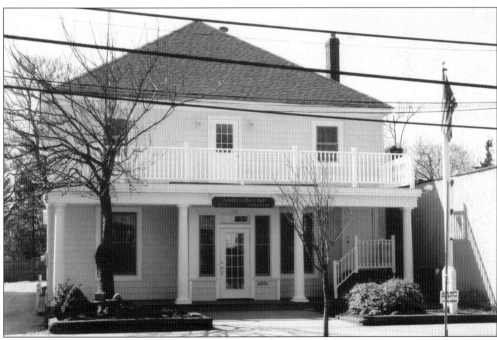
Established in 1897, the Amityville Club is located at 131 Merrick Road. It was recently restored.

The Amity Mall is one of several shopping centers in town. When this picture was taken, it included a record and CD store, a pizza restaurant, a coffee shop, and a catering business.

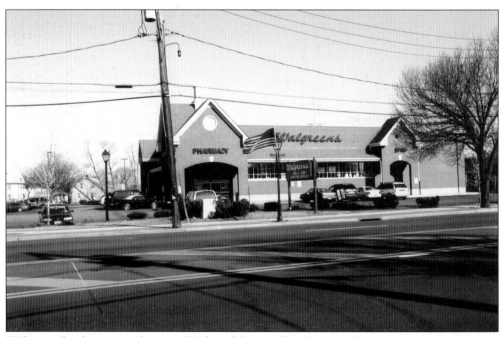

Walgreens has lampposts that are of Colonial design. This drugstore has a "drive-thru" pharmacy and is "open 24 hours."

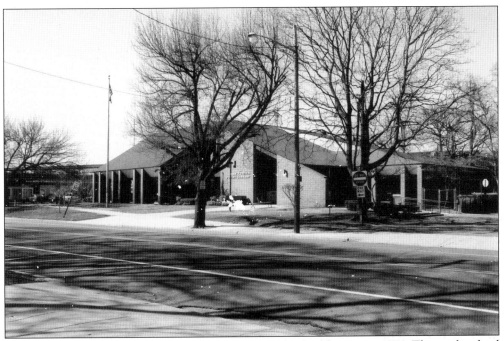

The Amityville Public Library has been located in this building since 1974. This is the third Amityville library building.

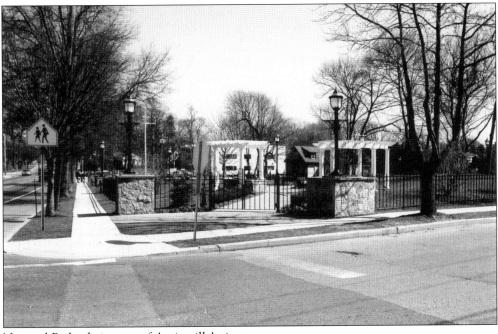

Nautical Park adjoins one of Amityville's rivers.

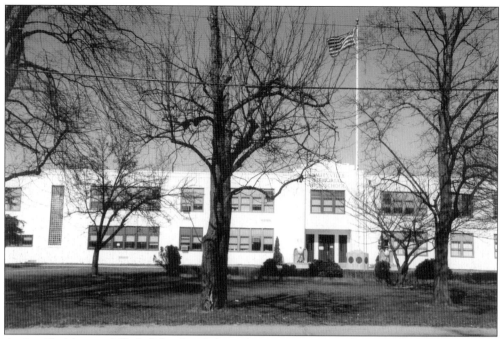

Amityville Memorial High School is dedicated in memory of residents who gave their lives in World War II. Note the carved birds on either side of the entrance.

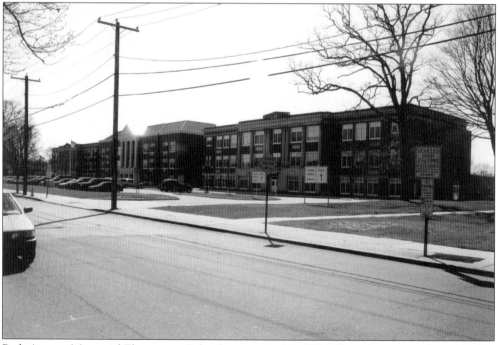

Park Avenue Memorial Elementary School was opened in 1924. Over the years, it has served as the high school, the elementary school, and the middle school. Its latest addition was completed in 2005.

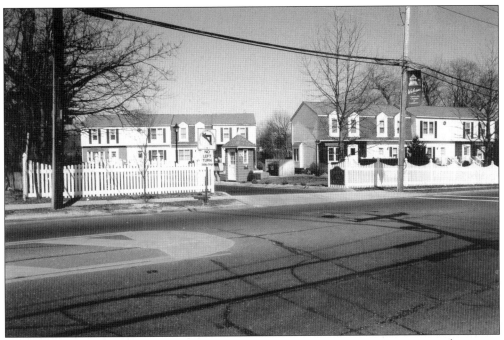

Located on Montauk Highway, Hidden Lake Estates is a cooperative apartment complex.

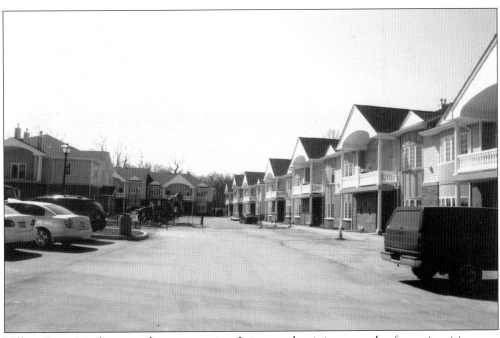

Village Estates is shown under construction. It is a condominium complex for senior citizens.

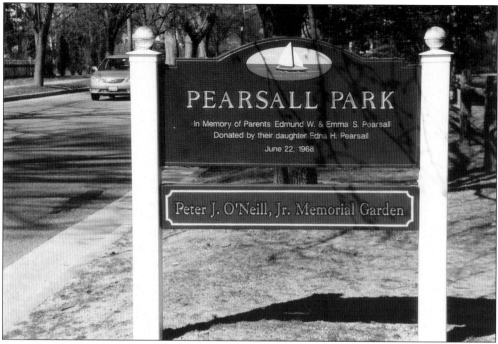

Pearsall Park was donated to the village on June 22, 1968, by Edna H. Pearsall in memory of her parents, Edmund W. and Emma S. Pearsall. It includes the Peter J. O'Neill Jr. Memorial Garden.

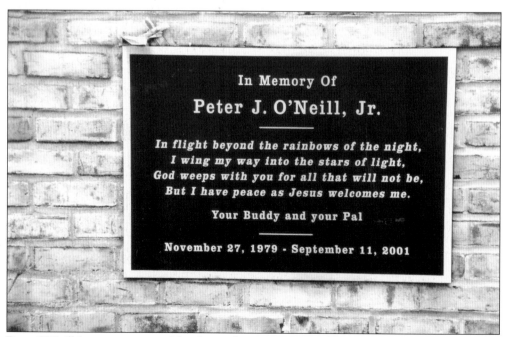

Peter O'Neill Jr. was a victim of the September 11, 2001, World Trade Center terrorist attacks. The memorial is in Pearsall Park.

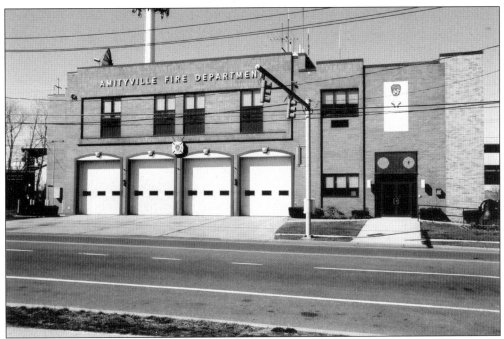

The Amityville Fire Department has four bays. It is the main firehouse in Amityville.

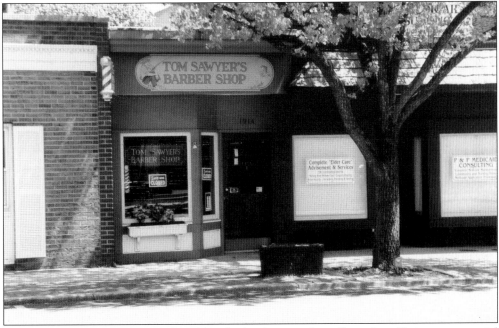

Tom Sawyer's Barber Shop is the oldest barbershop in the village. In addition to tonsorial services, the shop owner displays community spirit by decorating the front window for patriotic holidays and by setting up an elaborate train display at Christmas.

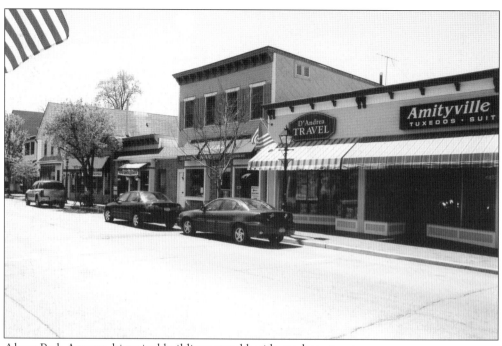

Along Park Avenue, historical buildings stand beside modern structures.

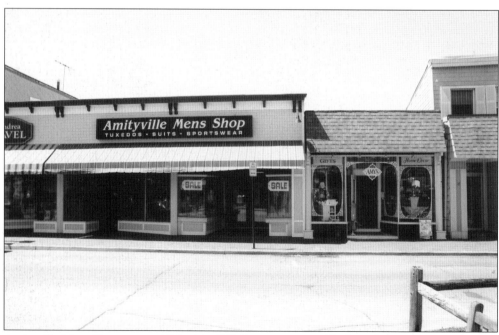

Amityville Mens Shop was established in 1911. It continues to offer "tuxedos—suits—sportswear" and accessories to the present day.

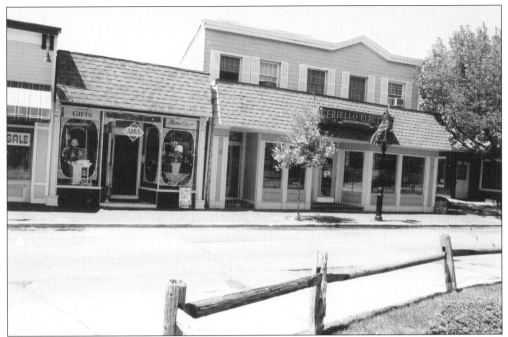

Two of Amityville's present-day businesses occupy this historic building. Ceriello Electric, established in 1943, advertises solar power, home inspections, and lamp repairs. Next door, Amy's (left) offers gifts and home décor.

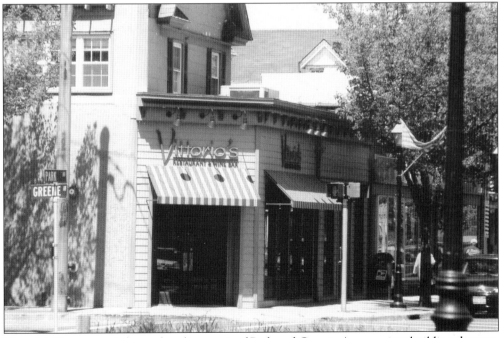

Vittorio's Restaurant is located at the corner of Park and Greene Avenues in a building that was erected in 1880. In the past the building has served as a butcher shop and as a pharmacy.

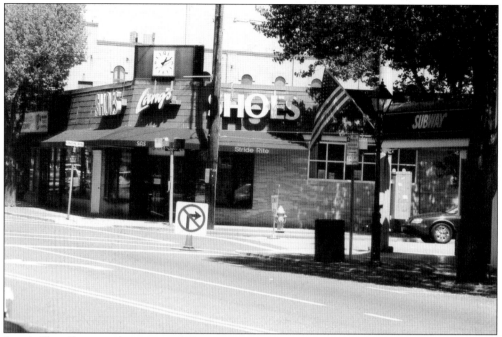

Lang's Shoe Store, at the corner of Union Avenue, was established in 1937 at another location, 184 Broadway.

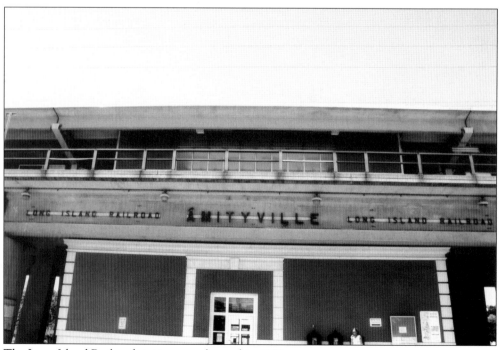

The Long Island Railroad station was elevated in 1973.

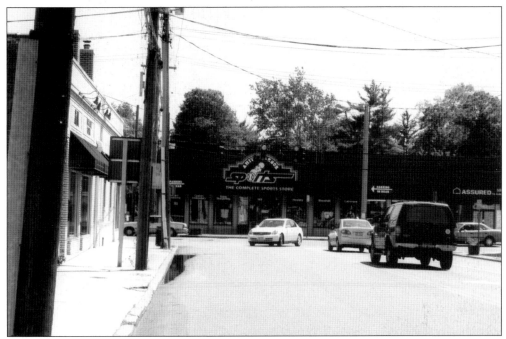

This is the terminus of Route 110 (Broadway), which intersects with Merrick Road. Amity Harbor Sports is straight ahead.

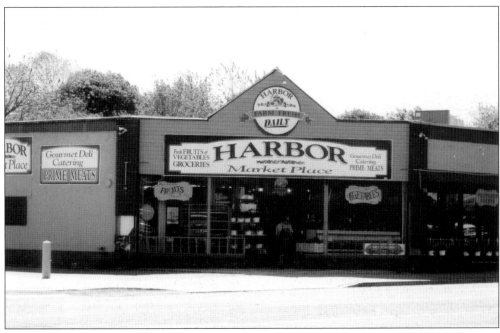

Harbor Market Place is known for its fresh produce, prime meats, and gourmet delicatessen.

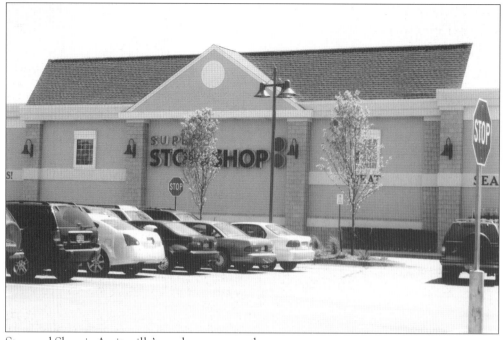

Stop and Shop is Amityville's modern supermarket.

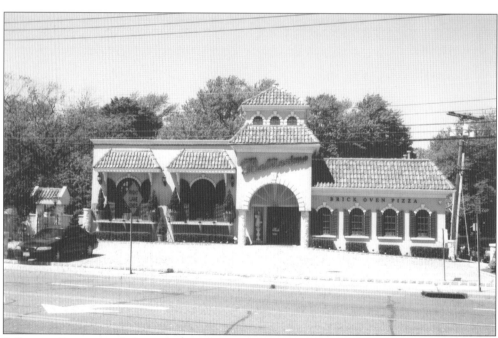

Bellissimo Restaurant Italiano is one of Amityville's dining establishments. Among its many selections is brick oven pizza.

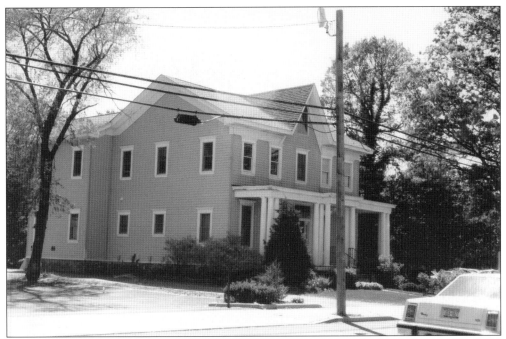

The 19th-century Baylis home was rebuilt exactly to its former design after being destroyed by fire.

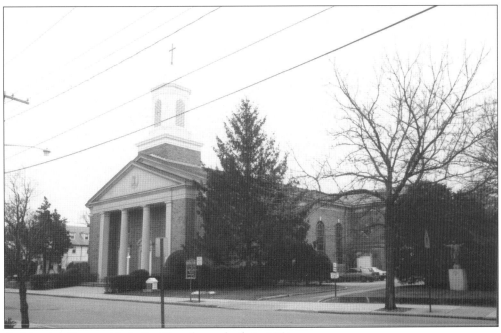

St. Martin's Roman Catholic Church was built in 1964.

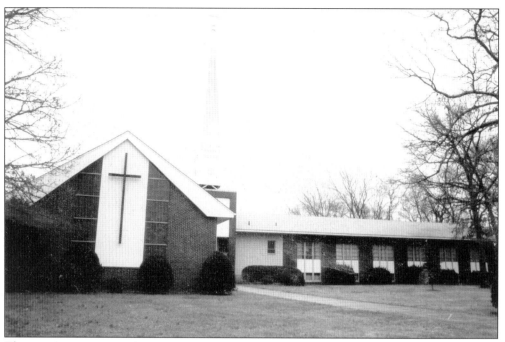

The new Simpson United Methodist Church was built in 1963.

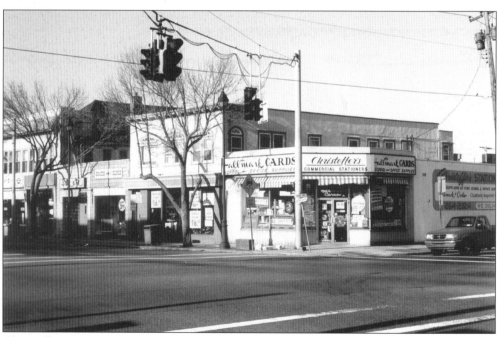

Christoffer's Commercial Stationers is still a popular meeting place.

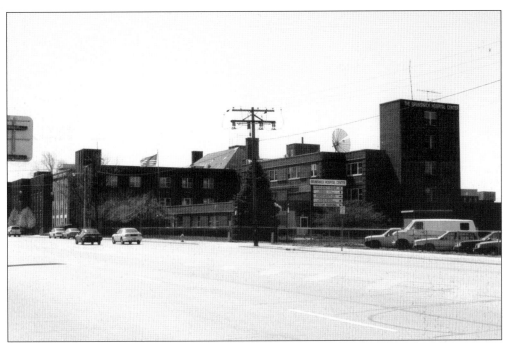

The Brunswick Hospital Center covers a lot of ground.

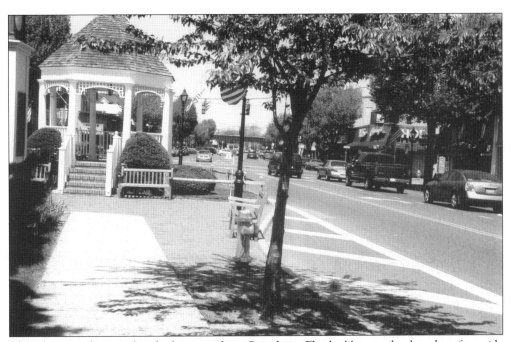

This photograph was taken looking north on Broadway. Flanked by wooden benches, five wide brick steps lead up to the gazebo.

Amityville, "the Friendly Bay Village on the Great South Bay," continues to extend a welcome

to all.

ACROSS AMERICA, PEOPLE ARE DISCOVERING SOMETHING WONDERFUL. *THEIR HERITAGE.*

Arcadia Publishing is the leading local history publisher in the United States. With more than 3,000 titles in print and hundreds of new titles released every year, Arcadia has extensive specialized experience chronicling the history of communities and celebrating America's hidden stories, bringing to life the people, places, and events from the past. To discover the history of other communities across the nation, please visit:

www.arcadiapublishing.com

Customized search tools allow you to find regional history books about the town where you grew up, the cities where your friends and family live, the town where your parents met, or even that retirement spot you've been dreaming about.